THE URBAN SKETCHING HANDBOOK

101 SKETCHING TIPS

Inspiring | Educating | Creating | Entertaining

Brimming with creative inspiration, how-to projects, and useful information to enrich your everyday life, Quarto Knows is a favorite destination for those pursuing their interests and passions. Visit our site and dig deeper with our books into your area of interest: Quarto Creates, Quarto Cooks, Quarto Homes, Quarto Lives, Quarto Drives, Quarto Explores, Quarto Gifts, or Quarto Kids.

© 2020 Quarto Publishing Group USA Inc.
Text © 2020 Stephanie Bower

First Published in 2020 by Quarry Books, an imprint of The Quarto Group, 100 Cummings Center, Suite 265-D, Beverly, MA 01915, USA.
T (978) 282-9590 F (978) 283-2742 QuartoKnows.com

Quarry Books titles are also available at discount for retail, wholesale, promotional, and bulk purchase. For details, contact the Special Sales Manager by email at specialsales@quarto.com or by mail at The Quarto Group, Attn: Special Sales Manager, 100 Cummings Center, Suite 265-D, Beverly, MA 01915, USA.

10 9 8 7 6 5 4 3 2

ISBN: 978-1-63159-765-7

Digital edition published in 2020

eISBN: 978-1-63159-766-4

Library of Congress Cataloging-in-Publication Data available

Front Cover Images: (top, l to r) Steven Reddy, Stephanie Bower, Stephanie Bower; (bottom, l to r) Shari Blaukopf, Eduardo Bajzek, Ben Luk
Back Cover Images: (top, l to r) Klaus Meier-Pauken, Stephanie Bower, Stephanie Bower; (bottom, l to r) Chih-Wei Lin, James Akers, Paul Heaston
Page Layout: Claire MacMaster, barefoot art graphic design
Illustration: Stephanie Bower

Printed in China

THE URBAN SKETCHING HANDBOOK

101 SKETCHING TIPS

Tips, Techniques, and Handy Hacks for Sketching on the Go

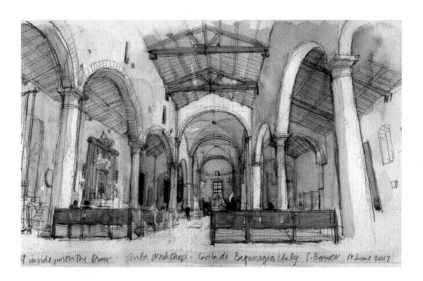

inside with the Draw · Arata Workshop · Civita di Bagnoregio, Italy · S. Bower · 12 June 2017

STEPHANIE BOWER

QUARRY

About This Series

The sixth volume in The Urban Sketching Handbook series, *101 Sketching Tips*, offers a broad collection of practical and fun tricks, techniques, and insights for sketching on the go. Whether you are new to sketching or a seasoned artist, whether your draw in pencil, pen, or paint, if you work on location or in a studio, this book shows you loads of tips to help you up your game.

The Urban Sketching Handbooks

Architecture and Cityscapes, Gabriel Campanario
People and Motion, Gabriel Campanario
Reportage and Documentary Drawing,
 Veronica Lawlor
Understanding Perspective, Stephanie Bower
Working with Color, Shari Blaukopf

**ᗷ JEONG SEUNG-BIN,
South Korea**

Heathrow Airport, London
(on a flight to Barcelona)

*5.75" x 8.25" | 14.8 x 21 cm;
Tachikawa Linemarker A.T
(waterproof ink pen) and watercolor
(Schmincke Horadam)
in Fabriano watercolor book;
About 30 minutes*

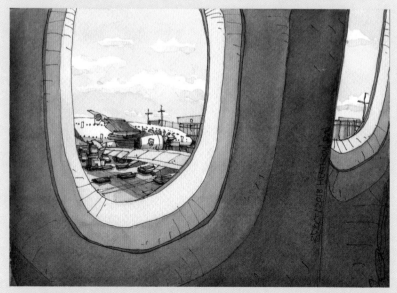

CONTENTS

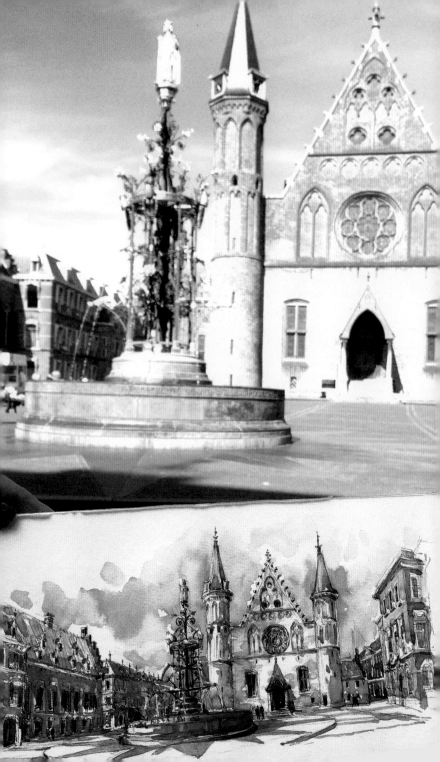

INTRODUCTION

Did you know that towers are like wedding cakes, trees are like umbrellas, and visualizing dairy products can help you paint in watercolor?

Some of my favorite and fun sketching "ah-ha" moments have to do with relating complex subjects to things we experience every day. I often use these concepts when teaching, as these metaphors can help us to demystify the sometimes challenging process of sketching the things we see.

This book is packed with a wide range of more than one hundred of my top tricks, techniques, and insights, all pocket-sized to travel with you on the go. Through a collection of amazing sketches, all done on location by artists from around the globe, you'll see these 101 tips magically come to life. From how to draw a line with energy to figuring out the anatomy of an arch, these insights will help you see familiar things in new ways as you discover sketching "ah-ha" moments of your own.

So, grab a pencil and sketchbook—or maybe a tablet and digital pencil— and let's go!

C Stephanie Bower, USA
Ridderzaal, Den Haag
8" x 16" | 20.3 x 40.6 cm;
Mechanical pencil and watercolor;
2 hours

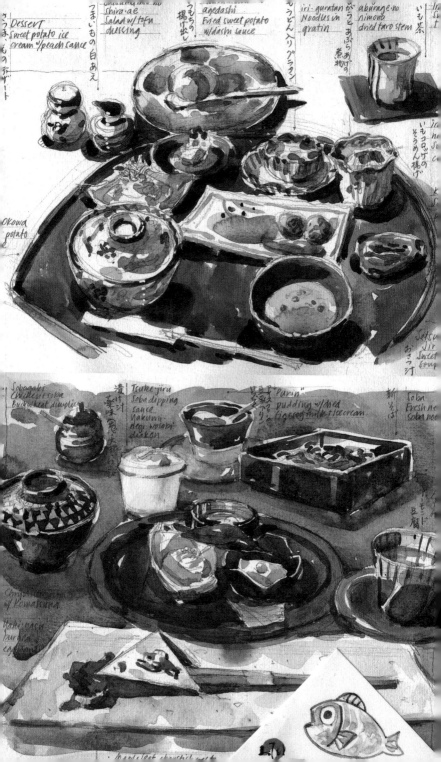

KEY 1
ON YOUR MARK, GET SET...

Are you ready for a sketching adventure?

Sketching is an amazing way to see the world—scratch that—it's an amazing way to see the world *better*. Sketching is popular all over the world for many reasons. It taps into your creative juices, and it calms and focuses your mind. It's a great way to learn about and remember the things you see and places you go. And it can connect you with other people and a sketching community. It's downright addicting.

Whether you sketch every day, when you travel, or only every once in a while, here are a few tips to get you ready for a great challenge and lots of fun.

◐ **STEPHANIE BOWER, USA**
Lunch & Dinner in Kawagoe, Japan
Japanese writing by Miyuki Yokota
7" x 10" | 17.8 x 25.4 cm; Mechanical
pencil and watercolor in Pentalic sketchbook;
1 hour each

● 1. Draw *and* paint on location, if you can.

Okay, sketching *and* painting on location is challenging. Everything is moving. People are watching. The water container just spilled. But it's so worth the effort.

Working on location is powerful. When you draw and paint from direct observation, the energy of the experience flows into your sketch and infuses it with life. Sketching is not about a perfect representation of what you see, but about capturing your unique experience. When you work on location, you'll see better and learn more. It keeps your sketch fresh, and it truly captures the moment in your heart and on paper.

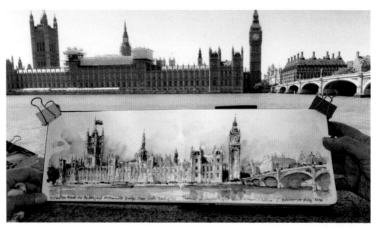

⋂ STEPHANIE BOWER, USA

Along the Thames with Anne and Beliza

5" x 16" | 12.7 x 40.7 cm; Mechanical pencil with 2B lead and watercolor in Pentalic Aqua Journal; 45 minutes

● 2. Travel light.

To draw and paint on location, portable equipment is essential. Urban sketchers are amazingly industrious when it comes to gear on the go.

Think small and light. Try a portable stool with aluminum legs instead of steel. Use lightweight corrugated plastic to make a desktop that sits on your lap. Use travel brushes that keep the brush tip protected. Carry separate bags for dry materials (e.g., sketchbook, pencils, erasers) and another bag for wet materials (e.g., watercolors and brushes, pens and ink, etc.). Put everything in a lightweight bag or backpack that is secure and won't weigh you down.

● 3. Start small.

New to sketching? Start small! It's much less intimidating to fill a small piece of paper, and you won't get sidetracked drawing too much detail. Try a small pocket-sized sketchbook that you can carry with you, so you are ready the moment inspiration strikes!

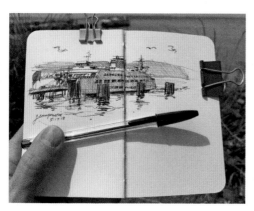

☾ GABRIEL CAMPANARIO, USA

Ferry Dock in Edmonds, WA

7" x 5.5" | 17.8 x 14 cm; Ballpoint pen on Stillman & Birn Epsilon Series pocket sketchbook; 30 minutes

Seattle-based sketcher and Urban Sketchers founder Gabi Campanario often carries a small sketchbook and a pen—simple tools to quickly capture any scene.

● 4. Start with a simple subject.

On a trip to India some years back, I met one other person who was also sketching. She excitedly pulled out a tiny sketchbook filled with images such as the top of a palm tree and the face of a camel—not the grand architectural masterpieces I was working so hard to create.

In so many ways, she got it right. It wasn't about creating great works of art; it was about capturing the meaningful moments of her trip. Her sketches were every bit as important to her as mine were to me.

The lesson here: don't be overwhelmed by thinking you need to create great works of art. Start simple, as it's all about capturing *your* experiences in a sketch.

➲ SUE HESTON, USA

Railroad Crossing

8" x 11" | 20.3 x 28 cm; Pen and ink in a hand-bound sketchbook; 10 to 15 minutes

Sue tells her story with simple, bold compositions.

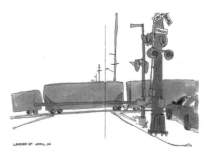

● 5. Treat yourself to a beautiful sketching tool.

An exquisite paintbrush, sketchbook, pen, or tablet can really inspire you to sketch more. Don't save it for when you are "better." The time is now!

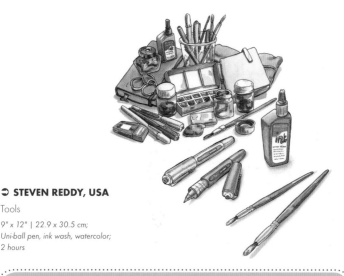

⊃ STEVEN REDDY, USA

Tools

9" x 12" | 22.9 x 30.5 cm;
Uni-ball pen, ink wash, watercolor;
2 hours

What is your favorite tool for sketching?

Shari Blaukopf: Travelogue Watercolor Journal sketchbook

Rob Sketcherman: iPad Pro, Apple Pencil, and Procreate (app)

Richard Hind: Uni-ball Eye Micro permanent ink pen

Ellie Doughty: 1.5 mm Parallel pen

Don Low: Hero fountain pen

Iain Stewart: Palomino Blackwing pencil

Stephanie Bower: Escoda Reserva travel watercolor brush, size 10

Suhita Shirodkar: Sailor Fude DE Mannen fountain pen (bent nib)

Paul Heaston: Fude nib fountain pens

Ian Fennelly: Tombow brush pen

Alex Hillkurtz: Faber-Castell Guilloche fountain pen

Richard Briggs: Artline Drawing System pens; drawing on found objects

alienbinbin: Cherry Blossom Brand needle tube pen & Moleskine sketchbook

● 6. Draw a lot.

Think quantity instead of quality. It takes lots of practice to get your hand, eye, and brain all coordinated.

Learning to draw is like learning a new language. It's challenging at first as you build your vocabulary, but through a lot of of trial and error, you will become fluent. Be persistent. The more you draw, the more you will like your drawings.

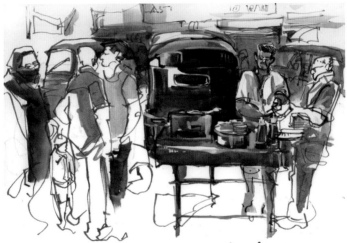

Rahul's Aloo Sandwich.

● 7. The more you draw, the more you'll figure out for next time.

Sketching is problem solving. Part of why beginners struggle is that they have to figure out so many things for the first time, such as how to represent a window or a tree. This is another reason why sketching a lot is helpful, especially at the beginning.

After you've tackled a particular problem in a few sketches, you won't have to figure it out again in future sketches. Sketching that window or tree will be easier because you've already worked out a drawing method you like, so next time, you'll know what to do. In the end, sketching gets easier the more you sketch!

⋒ SUHITA SHIRODKAR, USA & India

Rahul's Bombay Sandwich
9" x 12" | 22.9 x 30.5 cm; Watercolor, pen and ink; 30 minutes

Suhita sketches everywhere she goes . . . from fruit or flowers in her kitchen, to her kids at music lessons, to everyday scenes in action. She is fast and prolific, and it shows.

● 8. Draw where you are.

You don't have to be sketching in Venice to be inspired. Sketch a coffee shop, the house on the corner, or the pots and pans in your kitchen.

↻ JOSIAH HANCHETT, USA

Grand Rapids Kitchen

5" x 8.25" | 12.7 x 21 cm; Pen and watercolor; 1.5 hours

Even ordinary stuff in your daily life becomes extraordinary when you capture it in a sketch.

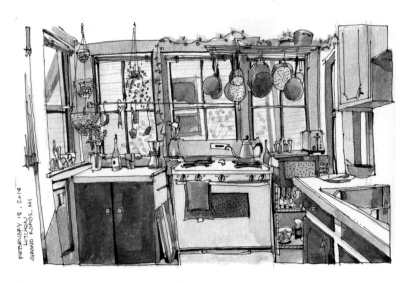

● 9. Don't wait to start until you are "good enough."

Here's the bad news: learning to sketch is a lifelong process. Even seasoned veterans produce duds and get frustrated. We are *all* always working to improve, so ignore that critical voice in your head and just jump in! Urban sketching is not so much about the destination, it's about the journey—and that is actually good news.

● 10. Don't try to find your "style."

Beginning sketchers often try different sketching styles like trying on different shoes to buy. While it's good to walk in another artist's shoes a bit to experiment and stretch, don't think too much about what others do—just do what you do naturally. Your hand is already unique, and the way you see the world is yours alone. The truth is, you already have a style! It will develop, improve, and emerge more clearly over time.

● 11. Embrace the audience.

Worried that if you sketch in public, people will see what you are doing? Embrace those curious onlookers. If they could do better, they'd be there sketching, too! Most people will be complimentary of your work and admiring of your courage—so smile, and hand them a card so they can find you online. Especially encourage curious kids, you might be inspiring a future artist!

Varanasi, India *Photo by Nancy Haft*

● 12. Make connections.

Why has urban sketching exploded into a global phenomenon? When traveling, I often ask people, "why do you like to sketch?" What I hear from nearly everyone is that it's all about *connections*.

Sketching connects us to our place and time. We have to look closely to record what we see and feel, imprinting this moment on our brains like no camera ever could.

Sketching connects us to our creative side. It quiets the mind and opens up our creativity and "flow," rather like a form of meditation. It actually feels good!

Sketching connects us to a community, be it in person or online, and this can be incredibly important. A connection to a friend or group can offer support, motivation, and inspiration. It has the power to change lives.

So, don't start this adventure on your own. Find an Urban Sketchers or plein air watercolor group, or even just a few friends to sit together and sketch in a coffee shop. Share what you do online. All these connections will make the process more rewarding and fun, and they'll motivate you to keep at it.

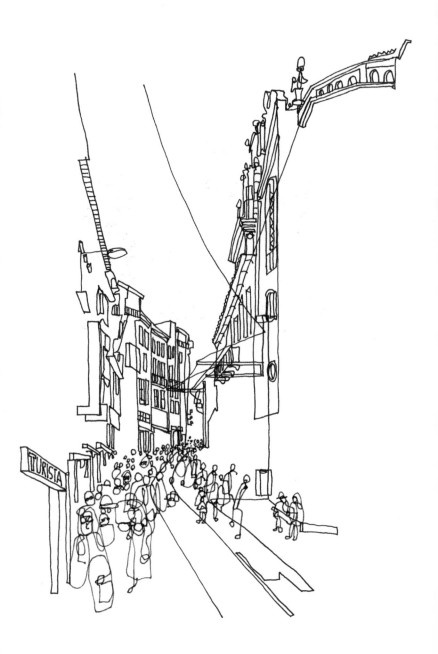

KEY II
IT ALL STARTS WITH A GOOD LINE

The foundation of nearly every sketch is a good line—be it in pen, pencil, brush, or on a tablet.

A good line invites you into a sketch with its energy and character. Amazingly, no two people can make the exact same line. Your line quality is like your signature . . . it is unique to you!

So, what exactly makes a line good?

☾ RICHARD BRIGGS, Australia

Não São Só Turistas, Porto 2018

11.7" x 8.3" | 29.7 x 21 cm; Ink pen on paper; Standing up, 15 minutes

Richard Briggs seems to draw an entire sketch with a single line, like magic. Because he draws with primarily one line thickness, he relies on his keen sense of perspective to achieve depth in this amazing sketch.

● 13. Experiment with different tools.

As far as habits go, sketching is relatively inexpensive. Try a variety of pencils, pens, brushes, and papers to find the combination that feels right for your hand and how much you bear down on the paper. Sometimes simply changing from one thickness of pen to another can make all the difference in the success of your sketch.

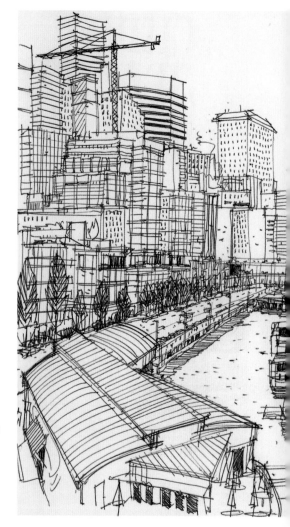

⊃ ANDIKA MURANDI, USA

Pier 66, Seattle

8" x 10" | 20.3 x 25.4 cm; Pen and ink in Moleskine sketchbook; About 45 minutes

Andika draws beautiful, clean, strong lines. You can feel the energy it took to make every stroke.

14. Draw clean lines.

Try to draw simple, clear lines, even if they are in the wrong place. Making ten lines in an attempt to place the right one only heavies up the line and calls attention to the struggle. Your line doesn't have to be perfect or in the perfect place. Avoid broken, hesitant, or "hairy" lines. Try drawing less with your hand and fingers and more with your arm and shoulder, as this will loosen up your lines and allow you to draw faster.

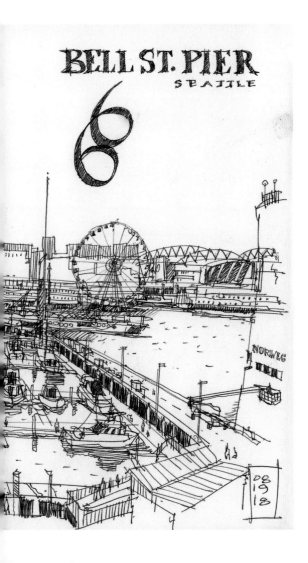

● 15. Draw long, straight lines in segments.

How many times have you heard, "I'm not an artist, I can't draw a straight line?" The truth is that almost no one can!

Try drawing a line in short segments. The trick is instead of overlapping the lines, leave a tiny gap. Your eye will naturally connect the segments into one long line. This can also help you compensate for the tendency to curve long lines due to the natural curve of your arm. And if your line is close to the edge of your paper, try stabilizing your hand by running your pinky finger along the edge as you draw.

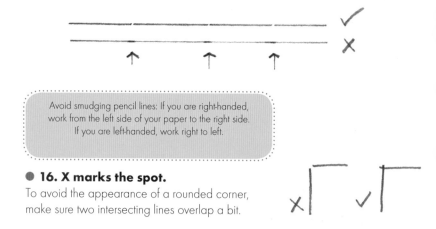

Avoid smudging pencil lines: If you are right-handed, work from the left side of your paper to the right side. If you are left-handed, work right to left.

● 16. X marks the spot.

To avoid the appearance of a rounded corner, make sure two intersecting lines overlap a bit.

● 17. The thickness of your line has meaning.

Like having a large vocabulary when you speak or write, understanding the vocabulary of line thicknesses is important to creating the story you want to tell in your sketch. If all your lines have the same thickness, your sketch can look flat and cartoony.

The thickness of your line, also called *line weight*, has meaning. In general, lighter/thinner lines recede in space and into the background of your sketch, while heavier/thicker lines tend to pop forward in space and appear closer.

When using a pen or marker that virtually has one line thickness, you have to vary your line quality by how light or hard you bear down on the paper. You can also try using a bent nib or parallel/calligraphy fountain pen.

Pencils offer more variety of lines than most pens because it's easier to get light and thin lines—as well as heavy and dark lines—based on how hard you press into the paper.

A Vocabulary of Line Weights

LIGHT LINE WEIGHTS

In general, there is no need to erase light lines. They disappear into the background and add to your sketch by revealing your drawing process.

CONSTRUCTION LINES
The first lines as you lightly block out your sketch. They are also the light lines drawn to figure out complex forms. To make these, barely drag your pencil or pen across the paper.

GUIDE LINES
Light lines used to help you locate or align elements, such as the tops and bottoms of rows of windows.

CENTER LINES
Drawn along the middle of something when you want to make sure both sides are symmetrical, as in the center of an arch.

WIRE-FRAME LINES
Skeletal X-ray lines drawn as if the form is transparent. Useful for understanding where things are in space or seeing the back side of a form.

MEDIUM LINE WEIGHTS

Most of the lines in your sketch will probably be medium-weight lines. Also consider the following lines:

CONTOUR LINES
Lines that follow the direction of a profile, slope, or curve, and help to describe the shape.

PROFILE LINES
Medium to heavy lines that define an edge. These can also help to indicate materials, such as brick or stone.

HEAVY LINE WEIGHTS

In general, these thicker lines appear closer to us in space. Also consider the following:

SNAP LINES
A heavy profile line used when there is space behind an object to pop the form forward.

SECTION/CUT LINES
These indicate a form has been cut; the heavy line is the part that is closest to you.

Denver Urban Sketcher Paul Heaston is an honest-to-goodness master of line drawing. He uses lots of different kinds of lines and line weights to make his sketches, both on paper and iPad. He starts by sketching his hands and paper in the foreground, then grows the sketch outward in a clockwise direction using his hands and book as reference for location and size. Amazing.

The decorative building details are simplified and suggestive of detail without drawing every tiny bit.

A buildup of lots of lines together is called "hatching," and it adds dark values to help define the shapes and add depth.

Different kinds of strokes indicate different materials, such as the wood shown here.

You can feel the energy of these lines because they were drawn quickly!

A heavyweight *snap line* around the bag pops the form forward in space, separating it from what is behind. Look for other heavy snap lines in this sketch.

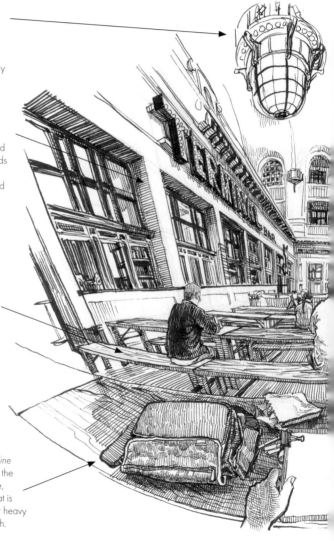

The absence of lines suggests light hitting the surface.

In the distance, lines appear lighter/thinner.

Contour lines that follow the curve of the ceiling tell us about the shape.

The lines along the edges of the sketch are masterfully composed and gradually feathered out to suggest that the forms continue.

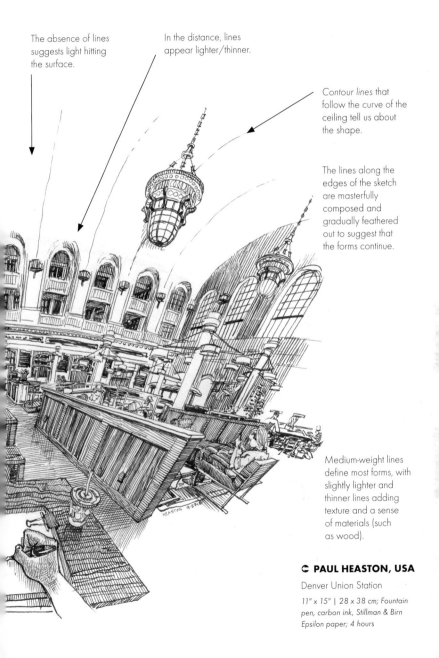

Medium-weight lines define most forms, with slightly lighter and thinner lines adding texture and a sense of materials (such as wood).

☾ PAUL HEASTON, USA

Denver Union Station

11" x 15" | 28 x 38 cm; Fountain pen, carbon ink, Stillman & Birn Epsilon paper; 4 hours

● 18. Draw lines with energy!

How you draw a line can either add life or deaden a sketch.
Here are a few ways to add energy and interest to your line work:

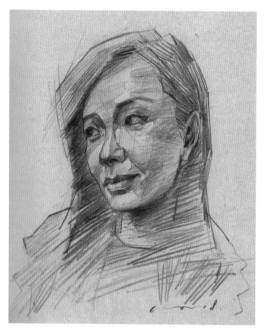

● Speed

Drawing quickly adds freshness and spontaneity to your lines. You can feel the speed in Wu's linework. If you are drawing too slowly, set a timer to make yourself sketch faster.

◠ WU JIANZHONG, Hong Kong

My Wife

6.3" x 8" | 16 x 20.5 cm; Pencils on sketchbook; About 40 minutes

● Wiggle

An intentional wiggle of your hand as you draw adds interest to the linework.

◠ STEPHANIE BOWER, USA

Mid-level escalator, Hong Kong

7" x 10" | 17.8 x 25.4 cm; Platinum Carbon pen and ink in Pentalic Aqua Journal; 1 hour

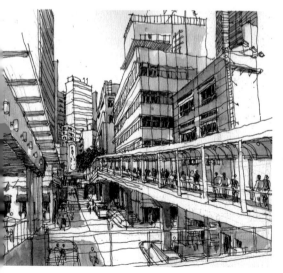

● Variation

Press hard, press soft, even pick up your pencil or pen to leave gaps. Try a bent nib pen or sketch with a twig and ink like KK to get a wide variety of lines.

↪ CH'NG KIAH KIEAN, Malaysia

Pura Dalem Kahyangan, Bali

15" x 11" | 38 x 28 cm;
Chinese ink on paper; 1 hour

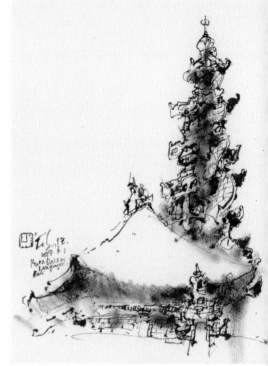

● Wonk

Yes, embrace the wonkiness of your line! Tilt it, curve it, all will add energy to your sketch.

↪ ROB SKETCHERMAN, Hong Kong

Towers of Taichung

6000 x 3000 pixels; iPad Pro,
Apple Pencil, Procreate (app);
2 hours

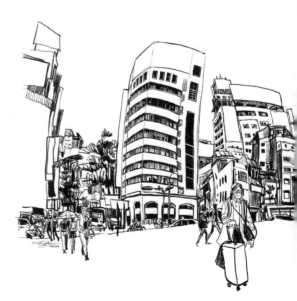

● 19. Think X-rays, draw wire frames.

To understand where things are in space, draw forms as if they are transparent using light *construction lines*. Draw what you see in your mind.

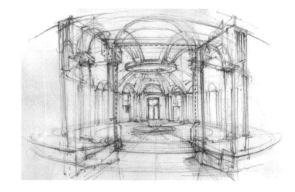

➲ **Jerome Tryon**

Woolsey Hall Sketch

8" x 10" | 20.3 x 25.4 cm;
2B lead, drafting pencil;
10–20 minutes

● 20. When drawing natural forms and materials, vary the line quality.

We tend to read man-made forms as having straight lines, while natural forms are suggested by irregular and broken edges. When drawing trees and leaves, wiggle and pick up your pen to break the line, bear down hard and light in the same stroke.

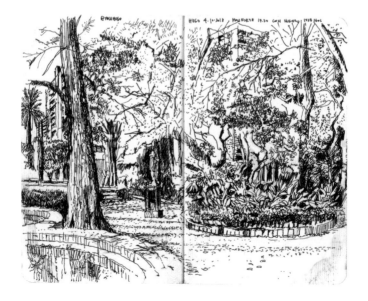

● 21. Showing building materials? Less is more.

No need to draw every brick! If you are adding texture to show materials like stone or roof tile, concentrate the linework, tone, and color around focal points such as doors, windows, and along edges. Let the linework gradually fade out in a natural way at the edges of your sketch. This will save you loads of time and the sketch will feel light and fresh.

⊃ ZHIFANG SHI, China

The Vanishing House

11.8" x 15.7" | 30 x 40 cm;
Ink on paper; 1 hour

It doesn't take much to show a tile roof! By not drawing in every tile, we see the sun hitting the surface.

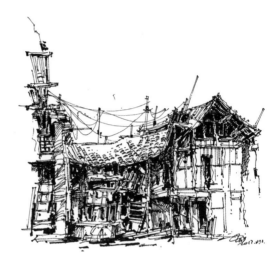

⊃ ANDREY SHMATNIK, Canada

Door in Jaffa

8" x 5" | 20.32 x 12.7 cm; Pilot fountain pen w/extra fine nib, watercolor in Pentalic Watercolor Journal; About 30 minutes

In Andrey's sketch, the stone's joint lines are lightly drawn and naturally fade out at the edges. The colors are loose and varied, and the dark doorway and black shadow add depth.

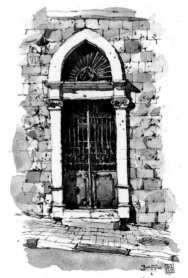

☾ HUGO BARROS COSTA, Portugal & Spain

Monforte Garden, Valencia

7" x 5.5" | 18 x 14 cm; Pilot G-TEC C4 pen on paper

● 22. Materials have thickness and depth.

Materials have three dimensions, so always show elements such as window mullions, chair legs, railings, a roof edge, etc. with at least two lines in order to read their thickness. You can't have too many lines around a window or door!

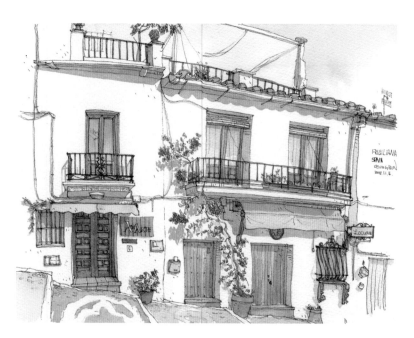

**∩ JEONG SEUNG-BIN,
South Korea**

Frigiliana, Spain

*9" x 12.4" | 22.7 x 31.6 cm; Uni Pin
fine line pen and watercolor (Schmincke
Horadam) in Holbein Waterford
watercolor paper white block; 50 minutes*

All the materials in this sketch—such as the balcony rail and the edge of the tile roof—have a realistic thickness because they are drawn with a minimum of two lines.

Be sure to draw the windows and doors as recessed, set back from the face of the wall to show depth.

● 23. Blacken small window panes for pop.

It works like magic! Be sure to fill the entire pane of glass and leave
the mullions white.

↻ **PAUL HEASTON, USA**

House on Gilpin Street

*6" x 4" | 15.2 x 10.1 cm; Pentel
Hybrid Technica pen, Hahnemühle
drawing paper; 1.5 hours*

● 24. To speed up, use a straight edge.

It can be challenging to draw long,
straight lines, so try using a clear ruler or
a 30/60 degree architect's triangle to
help speed things along.

 If, however, you find it slows you
down because you are trying to be too
accurate, just slip it back into your bag.

↪ **STEPHANIE BOWER, USA**

Lan Kwai Fong, Hong Kong

*16" x 8" | 40.6 x 20.3 cm; Mechanical pencil
and watercolor on paper; About 1 hour*

Hong Kong, the land of tightly packed,
tall and skinny buildings, is a great
place to use a straight edge to quickly
snap long lines. It made drawing this
16-inch-(40.6 cm)-tall sketch go
much faster!

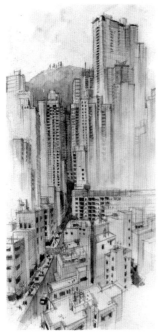

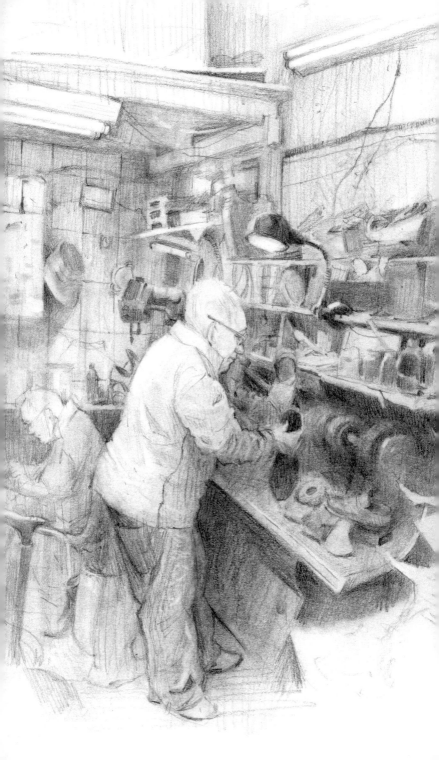

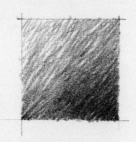

KEY III
THE VALUES OF TONE

White is provided by the white of the paper, and black is created by the black of your pen or pencil.

So how do you make all the shades of gray in between these two extremes?

**☾ EDUARDO BAJZEK,
Brazil**

Mr. Mavi–The Shoemaker

16.5" x 10.6" | 42 x 27 cm; 3B-6B pencils and blending stump; About 4.5 hours

Eduardo's delicate pencil sketch feels like velvet. Using a build-up of light lines, he achieves a sense of subtle depth and character.

● 25. Build up lots of lines to make tones.

When you draw lots of lines close together, your eye starts to read these areas as tones or shades of gray, values between white and pure black. This technique is called *hatching*, and it's very effective for adding muscle to the bones of your line drawings.

Hatching helps forms to read three-dimensionally. It also creates a sense of light and dark, and adds depth to the sketch. Understanding how values work is key to using color, too.

⊃ **KLAUS MEIER-PAUKEN, Germany**

Houses Quartier Latin in Paris

15.7" x 11.8" | 40 x 30 cm; Ink with fountain pen on white paper; 2 hours

Did you know that you can tell if people are left- or right-handed by the direction of their hatch marks?

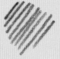

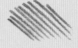

Right-handed people tend to draw strokes in this direction,

and left-handed drawers, including Leonardo da Vinci, usually draw strokes in this direction.

A Vocabulary of Hatch Marks

It's amazing how many different shading effects you can get with one tool by simply drawing different kinds of marks. If you are using pen, you have to add more lines to make darker values. This can be tricky, as some strokes are easier to blend than others.

You'll be drawing a lot of these lines, so find a stroke that is comfortable for your hand that you can draw quickly and repeat many times. Here are a few to try:

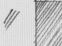

PARALLEL-LINE HATCH
This is the most commonly used hatch mark. Strokes are usually in one consistent direction and angle, something like a 45–60 degree slant. This hatch is difficult to make darker, as it's challenging to add more lines into the pattern.

FLAT-X HATCH
A mark that is easy to blend, easy to add more strokes to darken the values.

CROSSHATCH
Marks that cross each other like an X. The trick is putting them close enough together so that they read as a tone and not stripes or a checkerboard. Layer in more strokes to make values darker.

BASKETWEAVE
More time consuming, but it creates an elegant, earthy texture. Difficult to add strokes to make darker values once drawn.

CHICKEN SCRATCH
This mark can add lots of energy to a drawing. It's easy to add more strokes to make darker values, but it's time consuming.

SCRIBBLES
Looks busy and adds energy to a drawing. Easy to layer in more strokes for darker values.

DOTS OR STIPPLES
A time-consuming mark to make, but it's easy to add more dots to make darker values. The sound of making these marks, however, might drive other people crazy!

● **26. Make a value scale for reference.**

This is a great exercise to see how many different values you can get between the white of the paper and pure black. Try making 5 to 10 squares no larger than 1 inch (2.5 cm), with a gradual and even transition of values between each square. Experiment with different strokes.

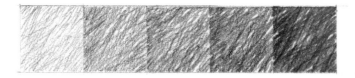

● **27. Leave bits of white between hatch marks.**

A complete blackout tends to feel flat and lifeless, so leave little bits of white in between your hatch marks, even in the darkest values. This can also be achieved when drawing in pencil on a paper that has some texture or "tooth." The nooks and crannies that the pencil lead doesn't reach will provide those bits of white so important for sparkle.

● **28. Draw hatch marks close together.**

Marks too far apart read as a pattern or stripes, not a tone. The strokes need to be close enough that your eye reads values and not individual lines.

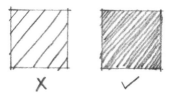

● **29. Schmears are only for bagels.**

Resist the temptation to turn a wood pencil on its side and smear. These marks tend to be fuzzy and deaden the sketch, as they obliterate the sparkles of white. Instead, use a hatching stroke or paper with a bit of texture.

If you don't want to rely on a pencil sharpener, try using a mechanical pencil. I use a 0.5 mm with 2B lead as it makes a clean, dark line. If you tend to smudge your pencil lines, try a harder lead such as HB. It's fun to buy inexpensive pencils as travel souvenirs. They'll provide a nice memory when you use them at home!

● 30. Hatch mostly in one direction, and blend well.

If you hatch in too many different directions, your sketch can look so busy that the marks become a distraction. In general, try to keep your hatch marks fairly consistent throughout your sketch. Blend the strokes to avoid making distracting "rivers" where the lines overlap.

➲ **STEPHANIE BOWER, USA**

View study, Tofuku-ji, Kyoto, Japan

5" x 8" | 12.7 x 20.3 cm; Mechanical pencil, watercolor; 5 minutes

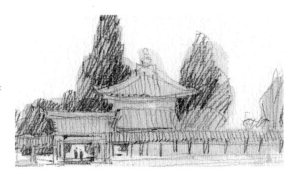

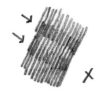

To keep pencil lines from smearing, paint a very diluted and barely visible light gray or yellow ochre wash over the lines.

● 31. Hatch to indicate the direction of a surface.

Hatching is also a great technique to define shapes such as curved surfaces (glasses and bottles below) or sloped surfaces (roof shown above.)

➲ **STEVEN REDDY, USA**

Cafe Racer, Seattle

12" x 9" | 30.5 x 22.9 cm; Uni-ball pen; 2 hours

Steven's sketch uses hatch marks in different directions to define specific forms, while still keeping the overall textures unified. The glasses and bottles read as rounded due to curved hatch lines. The flat floor shows horizontal marks; shelves and cabinet marks are vertical. Visually busy, but it all works!

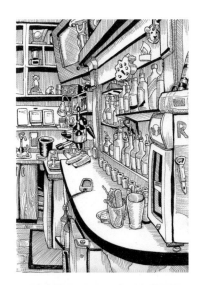

● 32. Build up lots of lines for visual interest.

Use a build-up of lines to create contrast, texture, and to draw your eye
into the sketch.

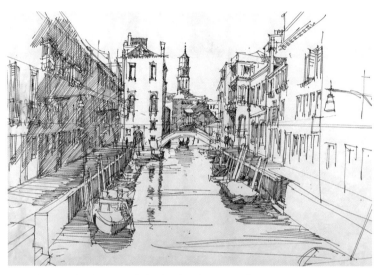

Klaus uses the classic parallel-line hatch to show
shade and shadow. Note that when drawn on flat
surfaces such as the water and sidewalk, the hatch
marks are drawn as horizontal lines.

**⋂ KLAUS MEIER-PAUKEN,
Germany**

Kanal am Campo Vio

*15.7" x 20" | 40 x 50 cm; Ink with
fountain pen on white paper; 1.5 hours*

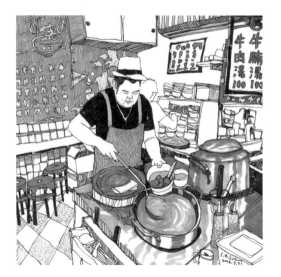

Our eyes are drawn to the
area of the greatest contrast,
that black shirt.

**↻ CHIH-WEI LIN,
Taiwan**

Street Vendor of Beef Soup

*8.3" x 8.3" | 21 x 21 cm; Pen,
pencil, marker; 1 hour*

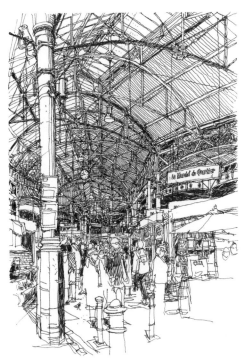

↺ **RICHARD HIND, UK**

Borough Market
(Le Marché du Quartier)

11.7" x 8.3" | 29.7 x 21 cm; Uni-ball Eye Micro permanent ink pen on A4 Daler-Rowney 150 gm2 acid-free cartridge sketchbook; 2 hours

● **33. Use a dark background to define an edge.**

The dark values of the trees define the edges and shapes of the building, popping it forward in space.

⊃ **CHIH-WEI LIN, Taiwan**

Shrine in Kyushu

8.3" x 6" | 21 x 15 cm; Pencil, pen, marker; 25 minutes

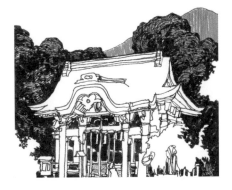

● 34. Vary values to show light.

Imagine you are in an all-white room. How do you see the corners and walls? What defines the shapes? No surface is a flat, single value. It's the subtle variations in shades of gray that allow us to see forms in space.

The same is true in your sketch. Varying values not only defines shapes, it is key to breathing light and life into your drawing. It takes a bit of strategizing as you'll need to figure out where the source of light is and how it will affect the values. Your eye will naturally be drawn to the area of the greatest contrast.

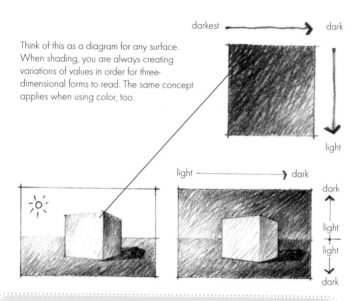

Think of this as a diagram for any surface. When shading, you are always creating variations of values in order for three-dimensional forms to read. The same concept applies when using color, too.

darkest ⟶ dark

light

light ⟶ dark

dark
light
light
dark

Key points to consider when shading:

- Think dark building against a light sky, or light building against a dark sky.
- Increase the contrast where two edges meet.
- Background/sky values change from left to right *and* top to bottom to indicate the Sun.
- Ground plane values change from foreground to background, often seen as darker when closer to you and fainter in the distance.
- The shady backside of a cube is lighter near the ground due to bounced light reflecting onto the surfaces.
- The shape of shadow is often darkest at the outer edges.

35. Vary values to show depth.

The doorway in the center looks like a flat, painted surface because it is all one value. The same opening on the right feels like there is open space beyond the door frame, achieved simply by varying the tone from dark at the top to lighter toward the bottom.

Like these doors, when toning any surface or shape, be sure to fill in the entire opening from edge to edge. Otherwise, you'll read an odd shape!

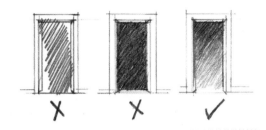

You can learn anything you've ever wanted to know about shading by studying the incredible work of 1930s New York architectural illustrator Hugh Ferris.

36. Shade or Shadow. What's the difference?

Did you know that shade and shadow are not the same thing?

Take a look at this image from Ronda, Spain. The Sun is on the left and when it hits the building it casts a dark **shadow** (1) onto the ground and wall. We see **shade** (2) on the backside of the form, opposite the source of light.

In general, shade is lighter and warmer in temperature. Shadow is darker and cooler.

This is important to know when you are shading, and it's really important when you are working in color!

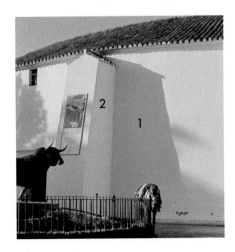

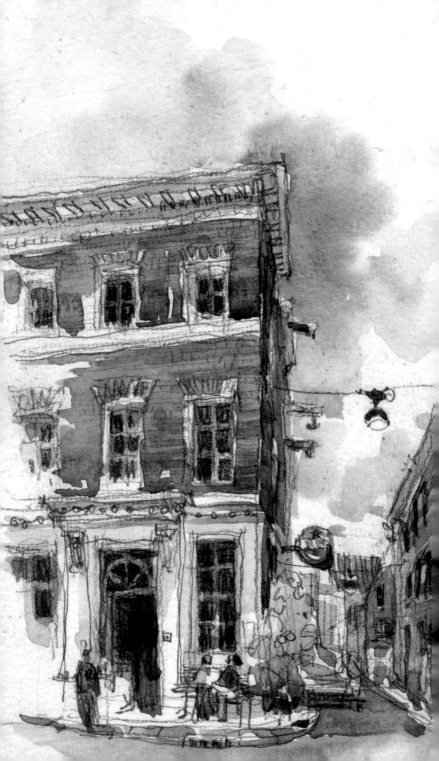

KEY IV
COMPELLING COMPOSITIONS

Take a moment to carefully look at the scene in front of you. Close one eye to flatten out the view, and you'll see it as a two-dimensional composition. Use your hands to crop what you see to figure out the extent of the view for your sketch. Take a photo, and see how it looks composed on your camera. What catches your eye? What story do you want to tell, and how will you tell it?

You have the power to create a relationship between your sketch and anyone who sees it. How you compose the sketch can catch their eye, entice them to enter its spaces, and show them something they haven't seen before.

This sketch of a café in Amsterdam uses two classic methods of composition: the rule of thirds and the golden section.

☾ STEPHANIE BOWER, USA

Corner Café, Amsterdam

5" x 8" | 12.7 x 20.32 cm; Pencil, watercolor, Pentalic Aqua Journal; 45 minutes

● **37. Consider composition basics.**

After you've assessed your view, it's time to think about composing your sketch. What information will you include and how will it be arranged on your paper? Will it be a tall or wide sketch? There are so many ways to create a compelling composition, but here are five tried-and-true methods to consider.

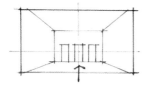

Symmetry
Equal on both sides, the focal point of the sketch is typically centered. Great for strong, classical architecture and to direct the viewer to a point in the distance. Be careful the composition doesn't become static and dull—go for power!

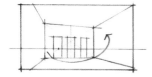

Asymmetry
A focal point that is off center on the page creates a visual imbalance that causes your eye to move around the page. This adds movement and energy to a sketch.

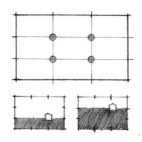

Rule of Thirds
Divide your paper horizontally and vertically into thirds, then locate the focal point of your sketch at one of the four spots where lines intersect. Locate edges along the lines. This method creates a pleasing composition every time.

It's also great for powerful high-horizon or low-horizon compositions.

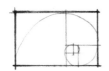

Golden Ratio or Section
Abundant in nature, this is the classical system of proportioning used by ancient Greeks that is remarkably harmonious to our senses. The ratio is approximately 1:1.6, so one unit high (or wide) and a little more than one and a half units wide (or tall).

Fun Fact: Your 5" x 8" (12.7 x 20.3 cm) sketchbook is already just about a perfect golden section!

Squares
A square-shaped composition allows you to compose interesting two-dimensional shapes using the negative and positive spaces of the page.

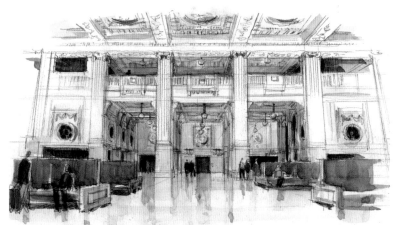

King Street Station Seattle - with Seattle Urban Sketchers and Good Bones Workshop Folks - 15 May 2016 - S.Bower for Sunny Spaces.

This sketch of a classical space uses symmetry to emphasize the formal design of the architecture.

⌂ STEPHANIE BOWER, USA

King Street Station, Seattle

8" x 16" | 20.3 x 40.6 cm; Pencil and watercolor; About 45 minutes

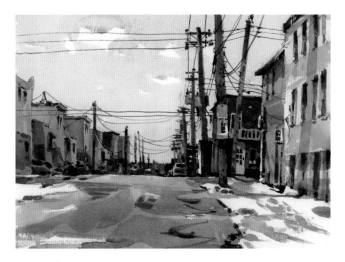

Shari uses the classic rule of thirds to compose this sketch.

⌂ SHARI BLAUKOPF, Canada

St. Louis and Sixth

11" x 14" | 28 x 35.5 cm; Pencil and watercolor; 1.5 hours

● 38. Create a strong focal point.

What element in the scene has intrigued you and caught your eye? Creating a strong focal point pulls the viewer's eye into your sketch and tells your story. You can choose to focus on anything—a person or an activity, a part of a building or object, a space. The possibilities are endless.

A drop of red is all it takes! Ben uses color to create a focal point by dropping in a simple splash of bright red that pulls your eye to the entrance of the building.

☾ BEN LUK, Hong Kong

Kun Ting Study Hall

8.3" x 8.3" | 21 x 21 cm; Pen and watercolor; 45 minutes

Tips for creating a strong focal point:

- Use contrast. The eye is naturally drawn to the area of greatest contrast of light and dark.
- Use a build-up of linework and detail.
- Use a build-up of color, a single strong color, or a pop of a bright color.
- Use a natural focal point, such as a tower or fountain, in the composition.
- Use the rule of thirds to locate your focal point.
- Use alternating lights and darks. Try a dark foreground, light middleground, and dark background to convey a sense of depth and help frame the view.
- Use perspective. It will naturally pull the viewer's eye in toward the vanishing point.

↻ IAN FENNELLY, UK

Plaça de Sant Francesc, Palma,
Majorca, Spain

*11.8" x 15.7" | 30 x 40 cm; Pen and
watercolor; 2.5 hours*

Centering the doorway in the
image, together with building up
the color and detail around the
door, creates a strong focal point.

A classic technique, a dark L- or
U-shaped frame in the foreground
intensifies the focus to the view
beyond. Alternating lights and darks
draws the viewer into the spaces of
the sketch.

↺ STEPHANIE BOWER, USA

Civita Street, End of Day

*5" x 8" | 12.7 x 20.3 cm; Pencil and
watercolor on Arches watercolor paper;
About 45 minutes*

● 39. Create no particular focal point.

A sketch can also just encourage your eye to wander . . .

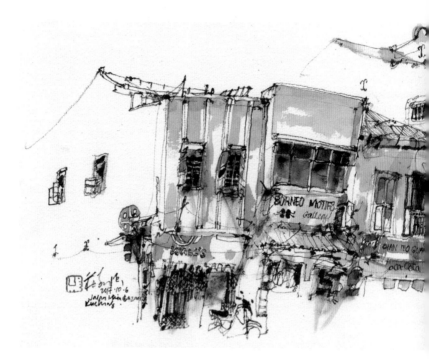

Malaysian sketcher KK is a master of lines that explore the spaces of his page. He creates beautiful textures that you can almost feel. Notice how his lines masterfully enter the sketch and lead you on a visual journey before you exit the piece.

As you see images online or on social media, try to notice what catches your eye. Why do you stop to look at one sketch and not another?

∩ ⊃ CH'NG KIAH KIEAN, Malaysia

Jalan Main Bazaar, Kuching (above)

11" x 30" | 28 x 76 cm; Chinese ink and watercolor on paper; 2.5 hours

Church of Notre-Dame-de-Bon-Secours, Brussels (right)

15" x 22" | 38 x 56 cm; Chinese ink and watercolor on paper; 2 hours

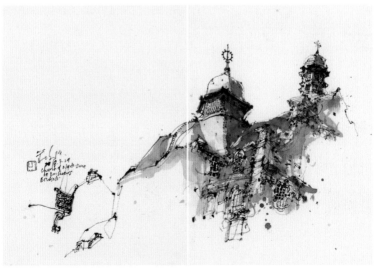

● **40. Frame the view.**

Creating a frame can both focus the view toward a focal point and also make drawing easier. Try using a frame created by a doorway or arch as a reference to compare locations and heights of things inside the frame's shape.

Using the center arch to create a reference frame, you can easily locate the arches beyond. It's helpful to draw light guidelines or tick marks.

◑ STEPHANIE BOWER, USA

Chiesa San Donato in Civita di Bagnoregio, Italy

8" x 16" | 20.3 x 40.6 cm; Pencil and watercolor on a Fluid watercolor block; About 1 hour

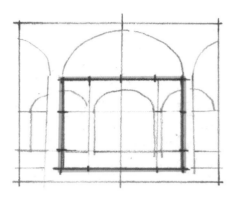

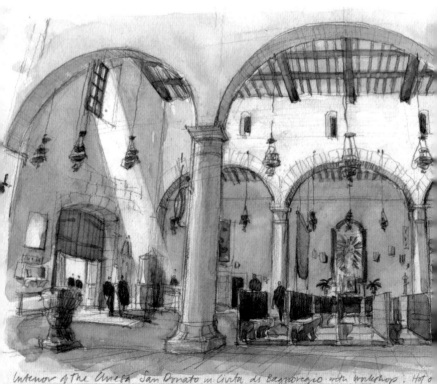

Interior of the Chiesa San Donato in Civita di Bagnoregio with workshop. Hot o

● 41. Study the composition with a quick thumbnail sketch.

You can quickly figure out a lot and shake off your nerves by first making a thumbnail sketch—about the size of a large postage stamp or small postcard. Thumbnails are great for studying composition, perspective, values, and even color.

I often do small thumbnail views in the back of my sketchbook. In only a few minutes, I can figure out the composition, the perspective, and where the focal point will be. They are so tiny, I can't get caught up in time-consuming details.

⌂ STEPHANIE BOWER, USA

Thumbnails

7" x 10" | 20.3 x 40.6 cm; Pencil and watercolor; 2 to 5 minutes each

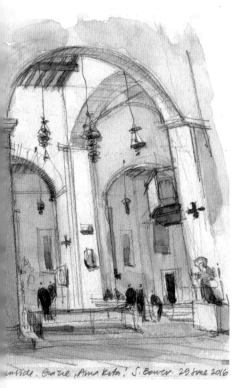

42. Avoid a corner in the middle of your page.

A corner in the middle of the page divides the view in two and pushes the viewer's eye out of the sketch. Put that corner to the right or left of center instead.

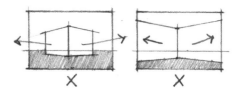

43. Don't block the vanishing point.

Odd though it sounds, people need to see where they are going to be pulled into a sketch. Allow the viewer to see all the way to the distance.

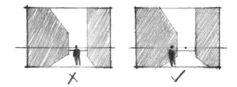

44. To understand space, show the ground.

A viewer needs to feel they can literally walk into the sketch.

45. To add movement to your sketch, tilt the ground.

Angling the ground and horizon on your page creates an imbalance that pushes your eye around the page, adding movement and energy.

● 46. To show lots of height or ceiling, start low on the page.

How many times do we start a sketch only to find the top of the tower is off the page? To show a tall building or space, or show lots of ceiling, place your eye-level line very low on the page to give your sketch room to grow.

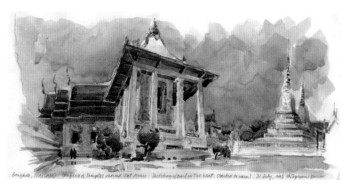

ᴖ STEPHANIE BOWER, USA

Wat Arun, Bangkok, Thailand

8" x 16" | 20.3 x 40.6 cm; Pencil and watercolor on Fluid watercolor block; About 1 hour

● 47. To show something is up high, put it high on your page.

The uppermost building on the right is close to the top of the paper, conveying a sense that is sited on top of a hill.

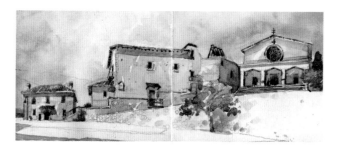

ᴖ STEPHANIE BOWER, USA

Casaprota, Italy

7" x 20" | 17.8 x 50.8 cm; Pencil and watercolor in Pentalic Aqua Journal; About 1 hour

● 48. Combine multiple views to tell many aspects of a story.

Many views placed together into one composition can tell a rich and layered story that is loaded with information. Creating a visual hierarchy of importance is key to combining multiple images. The image you want people to see first is usually largest and located on a prominent part of the page.

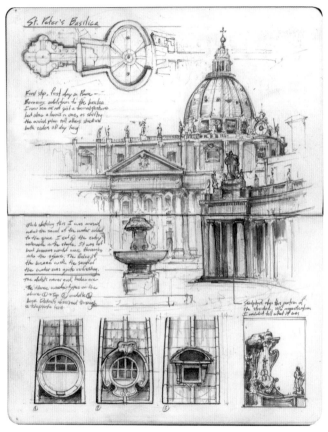

Jerome uses his sketchbook to record and study architecture. Note the hierarchy of images above. Your eye goes first to the largest image of Saint Peter's. Next a line of four smaller views ground the bottom of the page. Blocks of text add texture and information that support the graphic information. The total is greater than the sum of its parts.

⋂ JEROME TRYON, USA

Sketch of Saint Peter's in Rome

8" x 10" | 20.3 x 25.4 cm; 2B pencil, Faber-Castel PITT artist pen, Lamy Safari pen with Platinum Carbon ink; 1 to 1.5 hours

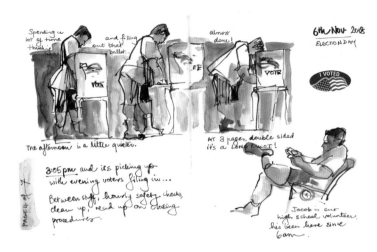

Another method of telling a layered story is to create multiple images in a linear sequence to indicate the passage of time.

Journaling is a very personal way to record an event or trip. Add notes, comments, titles, arrows, photos, ticket stubs . . . the possibilities are endless!

U ALENA KUDRIASHOVA, Russia & Singapore

Jimbaran Fish Market, Bali, Indonesia

9.6" x 13.4" | 24.5 x 34 cm; Lamy fountain pen (M nib), Platinum Carbon ink, water brush, watercolor; 2 to 15 minutes per sketch

Ω SUHITA SHIRODKAR, USA

Election Day

10" x 16" | 25.4 x 40.6 cm; Watercolor, pen and ink; 30 minutes

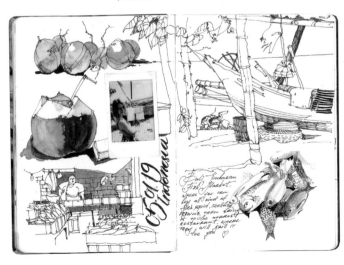

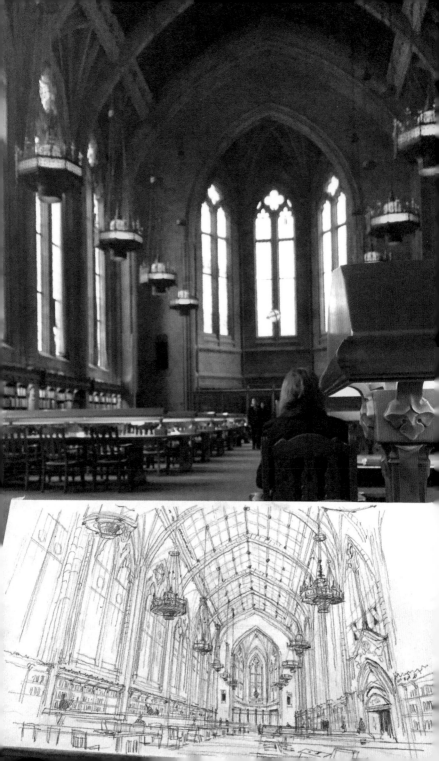

KEY V
GOOD BONES

You are staring at that huge blank sheet of paper thinking, "Yikes, what do I do now? How am I going to get this wide, complicated scene onto my small, flat piece of paper?"

While lots of people approach sketching in different ways, most good sketches start with good bones. These are the initial foundation lines of your drawing or painting, and they usually involve perspective. Feared, faked, or just plain ignored, perspective is actually pretty easy when you know what to look for. Understanding a few key principals will make your sketch more accurate, and it will make the process of sketching both easier and faster.

There are numerous books on perspective, including *Understanding Perspective* in this Urban Sketching Handbook series, so here are just a few more tips to help you up your game.

And you can breathe a sigh of relief because perspective doesn't have to be perfect, just believable!

☾ **STEPHANIE BOWER, USA**

Suzzallo Library Reading Room at
the University of Washington

8" x 16" | 20.3 x 40.6 cm; Mechanical
pencil on Fluid watercolor block;
About 1 hour

● **49. Sketch like an artist. Grow your sketch.**

How does your mind work? Does your eye go first to detail or to shapes and spaces?

Many sketchers with a background in art start by sketching the part of the view that first catches their eye, then adding to or "growing" their sketch out from that starting point. This works well if at the beginning you can visualize how everything will eventually sit on your page in the end.

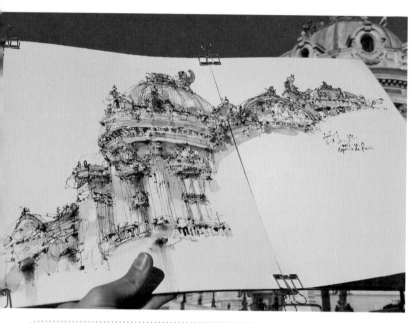

Over the years, I have observed that different people approach sketching in different ways and for different reasons. For some, like many architects, sketching is all about learning from what they see. These sketchers look carefully, absorb information, and record the experience with a certain amount of accuracy.

For some sketchers, including many artists, the process is more about capturing an impression of their experience. Their sketch might be more about gestures and loose colors; they want to capture a feeling or tell a story.

Which type of sketcher are you?

⋒ CH'NG KIAH KIEAN, Malaysia

Opéra de Paris

15" x 33" | 38 x 84 cm triptych; Chinese ink & watercolor on paper; 2 hours

KK starts with one page, then adds more pages as he grows his sketch. He draws with ink and twigs that he and his father cut from a tree near his home.

● **50. Sketch like an architect. Start with the big shapes.**

Architects tend to sketch the way they think, by visualizing the overall scene as simple shapes. This involves reducing complex buildings and spaces to simple squares, rectangles, triangles, and circles. Even if you are not an architect, you can train your eye to see this way.

Once these shapes are quickly blocked out on paper, a lot of the work is done as you've created a sort of road map to follow as you build your sketch in layers. You'll know right away if everything will fit!

1. Start with the big shape at the end of the room (orange), as it defines the shape of the entire space.

2. Next find the vanishing point (orange) and mark it within the big shape.

3. Draw in your eye-level line (blue) across the page. You now have all the foundational "good bones" you need to create your sketch!

◔ STEPHANIE BOWER, USA

Suzzallo Reading Room at the University of Washington

8" x 16" | 20.3 x 40.6 cm; Mechanical pencil on Fluid watercolor block; About 1.5 hours

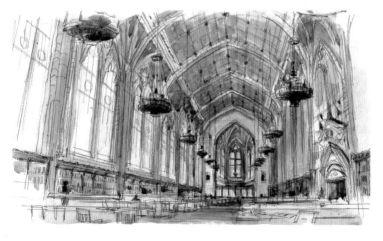

● 51. Edit what you see to simple shapes.

Look for the big shapes that define the height and width of spaces. When you start to see forms as simple shapes, it's easy to shrink and draw them onto your paper to start your sketch.

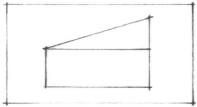

∩ STEPHANIE BOWER, USA

Il Giardino, Civita di Bagnoregio
*8" x 16" | 20.32 x 40.64 cm;
Mechanical pencil on Fluid watercolor
block; 1.5 hours*

● 52. Start with light *construction lines,* and don't erase.

When blocking out the initial lines of your sketch, draw lines that are barely visible. These will simply blend into the background of your sketch. If you do see them, they reveal a bit of your drawing process.

● 53. Find a reference line for measuring.

If you are going to start a sketch by blocking out the big shapes, what's the first thing to look for when you sit down to sketch? A *reference line* in your view, ideally a vertical line at a corner. You will use this line to measure the heights and widths of the shapes—their *proportions.* It's also the first line that you'll draw on your paper, and its size on the page will determine the size of your sketch.

● 54. Use your pencil or pen as a measuring stick.

Your pencil or pen is a useful tool for measuring things in your view. Close one eye and hold out your pencil, moving your arm back and forth until it aligns with the height of your corner reference line. Lock your arm, and now you can use your pencil to measure the relative heights and widths of everything in your view. For example, a shape could be one pencil high and two pencils wide.

This photo shows the edge I typically use as a reference or measuring line. It's usually a vertical line at a corner or edge of a building. Once I align my pencil with that edge, top to bottom, I can use my pencil to measure the heights and widths of the big shapes needed to start my sketch.

I'm not transferring the actual height of my pencil to my paper, just an understanding of the proportions I've measured. This shape is 1 pencil high and about 1⅓ pencils wide.

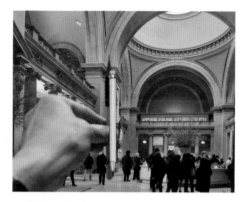

⊃ STEPHANIE BOWER, USA
Metropolitan Museum of Art, NY
8" x 8" | 20.3 x 20.3 cm; Mechanical pencil and watercolor in HandBook sketchbook; 1 hour

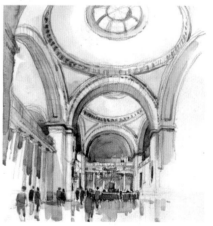

● 55. Start slowly and carefully, then pick up the pace.

Spend some time at the beginning to carefully place the initial lines correctly. Once the good bones are in, let your hand fly! Your sketch should speed up as you go and working quickly will add energy.

● 56. Understand the first rule of perspective.

Probably the most important concept in perspective drawing is this:

Lines that are parallel to each other appear to intersect at one point in the distance.

Visualize the classic railroad track. We know the rails are equally spaced the entire length, but our brain makes it look as if they cross each other in the distance. This point where they intersect, or converge, is called the *vanishing point* (VP), and it's the key to generating perspective drawings.

Every set of parallel lines you see will have its own VP. For example, a building on a corner has two visible sides. All the lines on the left side that are parallel to each other will recede to one VP on the left. Lines on the right side are not parallel to those on the left, so they will have a different vanishing point on the right. Seeing both sides generates a two-point perspective.

Here's the amazing part: *both* points will be at your eye level!

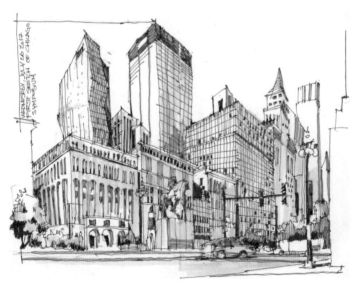

**∩ JOSIAH
HANCHETT, USA**

Michigan Ave., Chicago

*5" x 5" | 12.7 x 12.7 cm; Pen
and Tombow markers; 1 hour*

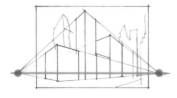

● 57. How you look at your subject determines your perspective.

Lots of us understand the concept of perspective when visualizing boxes on a table. But what if you are sitting on a street or in a room and you want to draw it? How do you find your VPs? What makes one drawing a one-point perspective and another have two vanishing points? It's simple. It's how you are looking at your subject—it's your relationship to what you are sketching.

If you sit or stand and you look straight on at your subject, you'll have only one set of lines that are receding into the distance, creating a single vanishing point. Move even slightly to look at your subject at an angle—now you've got a two-point perspective, with both VPs on a line at your eye level.

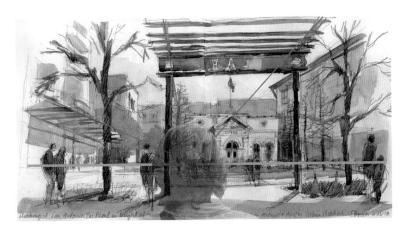

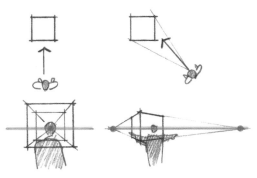

⋂ STEPHANIE BOWER, USA

The Pearl, San Antonio

8" x 16" | 20.3 x 40.6 cm; Pencil and watercolor. About 45 minutes

In this perspective, the primary vanishing point is directly in front of me at the height of my eyes above the ground, on my eye-level line.

● 58. Know your view options.

There are lots of different kinds of views in perspective, so you have many choices! Your perspective is unique to your viewpoint, and it is determined by how you are looking at your subject.

When describing perspective views, we use both the number of vanishing points (which describes the angle at which you are viewing your subject) together with your eye level (the height of your eyes above the ground). Combine these and make your own perspective recipe!

Number of Vanishing Points
How you are viewing your subject.

ONE-POINT
Looking straight ahead at
your subject.

TWO-POINT
Looking at your subject at
an angle.

THREE-POINT
Looking up (verticals angle up)
or down (verticals angle down)
to an additional VP. Angled
vertical lines exaggerate height
or depth.

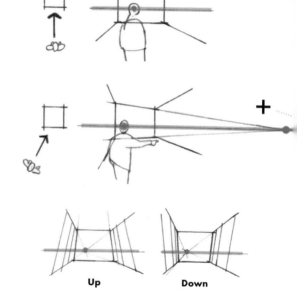

Up **Down**

WIDE ANGLE
Verticals angle up to a third
VP at the far sides.

or **UMBRELLA**

Horizontals curve, sometimes
verticals, too, to show wide,
undulating space.

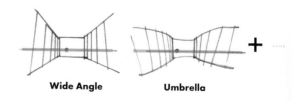

Wide Angle **Umbrella**

You can mix and match these terms. For example, you can have a one-point/aerial view, a two-point/eye-level view, a three-point/worm's eye view, and so on.

◡ STEPHANIE BOWER, USA

Vaux-le-Vicomte (top); Medieval Oxford (center); Chiesa di San Donato (bottom)

Pencil and watercolor; About 1 hour each

Your Eye Level
The height of your eyes above the ground.

AERIAL VIEW =
Your eye level is high above the ground.

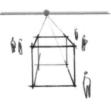

ONE-POINT/AERIAL VIEW

EYE-LEVEL VIEW =
Your eye level is about 5' (1.5 m) above the ground.

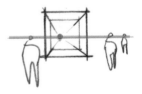

TWO-POINT/EYE-LEVEL VIEW

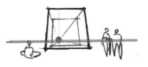

WORM'S-EYE VIEW =
Your eye level is low, relative to your subject or other people, or you are sitting.

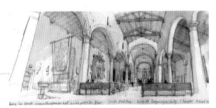

THREE-POINT WIDE ANGLE/WORM'S-EYE VIEW

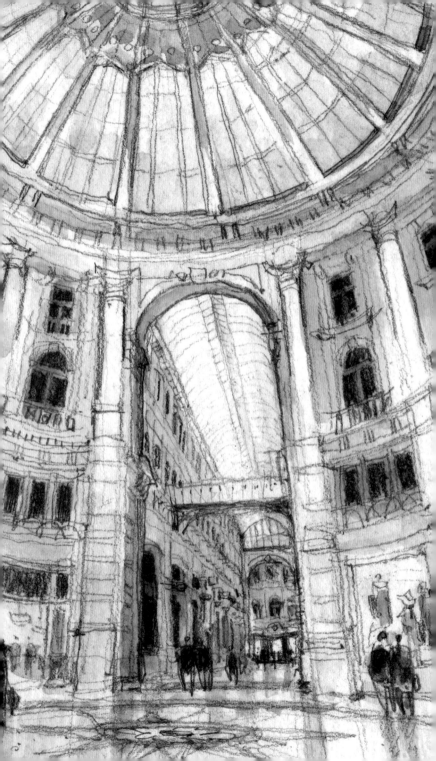

KEY VI

IT'S ALL ABOUT YOUR EYE LEVEL

Your eye-level line is not only important because it is where most of the vanishing points can be found, it's useful in all kinds of amazing ways.

Even though the focus of this sketch is looking up to the glass dome, the eye level and vanishing point for the perspective are low and close to the ground.

◌ STEPHANIE BOWER, USA

Passage Den Haag

8" x 5" | 20.3 x 12.7 cm; Mechanical pencil and watercolor in Pentalic Aqua Journal; About 45 minutes

● 59. Think eye level, not horizon line.

We know that when parallel lines recede from us, they appear to intersect at one point in the distance called the vanishing point (VP). That point is on what is typically called the horizon line, literally the line at the horizon where the flat ground or ocean meets the sky.

The problem with this term is that unless you are sketching at the beach, you probably won't see the horizon. It's more useful for sketchers to think of this important line in a different way. Lucky for us, we have a unique relationship to the horizon line—it aligns with our eye level!

Take a look at this photo from Venice. I'm standing on an upper floor looking down, and the line where the water meets the sky, the horizon line, is literally at my eye level. The VPs for the buildings are also on this line.

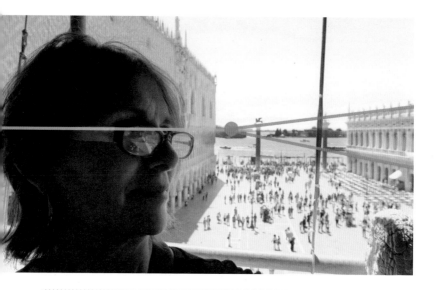

If you are standing, your eye-level line is about 5' (1.5 meters) off the ground.

If you are sitting, your eye-level line is about the height of a door handle.

Always draw your eye-level line all the way across your sketch. It's a useful reference.

● 60. Lines appear flatter the closer they are to your eye level.

Technically speaking, this concept is called *foreshortening*. The closer lines and shapes are to your eye level, the flatter they appear, and they completely flatten to a horizontal line *at* your eye level. Knowing this is useful for drawing all kinds of things such as floor lines on buildings or courses of brick or stone. The flattening of lines indicates where you can find your eye-level line and vanishing points, too.

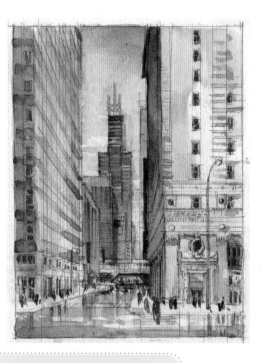

⊃ STEPHANIE BOWER, USA

Chicago

6" x 4" | 15.2 x 10.2 cm; Mechanical pencil, watercolor in Pentalic Aqua Journal. 45 minutes

Need help finding your vanishing point? Shoot an arrow!

In a one-point perspective, you should be standing and looking straight ahead. Your line of sight is perpendicular to the face of your subject.

To find the one vanishing point, imagine you are shooting an arrow. Don't tilt up or down, shoot that arrow at your eye level and where it hits directly in front of you is your VP.

For a two-point perspective, hold your arms out at your eye level and parallel to the sides of the building you are drawing. Your hands will point to the two vanishing points!

● **61. Lines above eye level angle *down*. Lines below angle *up*.**
Once you find your eye-level line is, it's easy to figure out where other lines go.

Lines *above* your eye-level line (blue) will angle *down* to a vanishing point (orange), while lines *below* your eye-level line will angle *up* (pink).

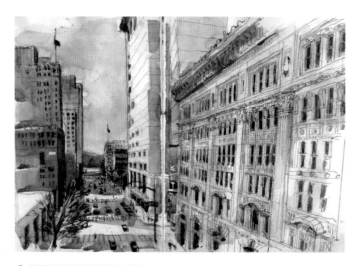

⌒ STEPHANIE BOWER, USA

Downtown Seattle

8" x 16" | 20.3 x 40.6 cm; Mechanical pencil and watercolor in HandBook sketchbook; 1.5 hours

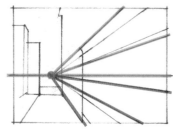

● **62. Don't bump your head!**
A common error is to draw the tops of doors angling *up* in a street view. The top of a door is above your head and thus above your eye level—it has to angle *down* to the vanishing point! Drop in a person to check!

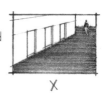

X

✓

● 63. For curves, think cup *up* or cup *down*.

In perspective, rounded forms appear as ellipses. At your eye level, shapes flatten to a horizontal line. Use both these concepts to correctly draw curves!

If you are standing *inside* a curved space:
Curving lines *above* eye level are "cup up," that is, they can hold water.
Curving lines *below* eye level are "cup down," that is the water spills out.
If you are standing *outside* the curved space, it's the opposite!

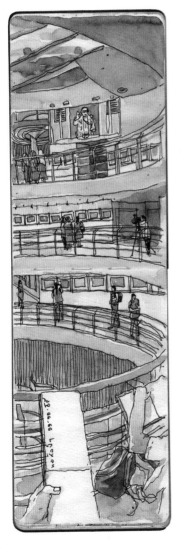

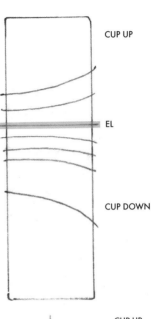

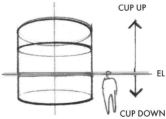

◯ PRAYUT SAE-AUNG, Thailand
Bangkok Art and Culture Centre
16" x 5" | 40.6 x 12.7 cm; Sakura Pigma Micron 0.50 mm and watercolor in Moleskine large watercolor notebook; About 40 minutes

● **64. If a building face twists left or right, its VP twists left or right, too, . . . along your eye-level (EL) line.**

Lots of modern cities are built on a grid pattern, and that makes drawing in perspective relatively easy. But what if you are in Paris or Old Delhi? Remember, lines that are parallel to each other recede to the same VP. This means that every surface that twists off the grid will generate a new VP!

If a surface twists to the *right*, its VP shifts to the *right* along your EL line.
If a surface twists to the *left*, its VP shifts to the *left* on your EL line.

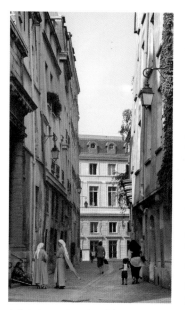

At first glance, the sides of the street look parallel.

But in extending building lines and finding the VPs, we discover they are not!

● **65. Don't use the ground to find your vanishing point/s.**

If the ground plane is even a little bit sloped, it will throw off the location of your vanishing point! Instead use the horizontal lines on the buildings. It's more likely that the tops of windows, decorative moldings, and roof edges will be true flat, horizontal lines receding to the VP on your eye-level line.

● 66. If a surface tilts up or down, its VP pops up or down, too, relative to your eye-level vanishing point.

A flight of stairs, a slanted roof, an uphill road . . . each is a surface that slopes up or down and will generate a new vanishing point up or down.

If a surface slopes *up* and away from you, its VP will pop *up*.
If a surface slopes *down* and away from you, its VP will pop *down*.

The trick is that these new vanishing points are typically directly above or below the vanishing point on your eye-level line!

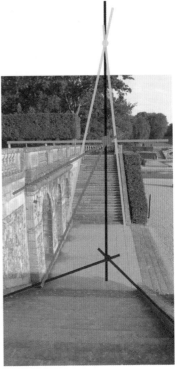

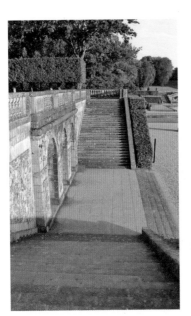

1. Start by finding the vanishing point at your eye level (orange). 2. Draw a vertical line through that point (gray). 3. Extend the lines at the edges of the stair to find the vanishing point in the sky (yellow) or below the ground (red).

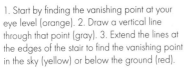

Downhill slopes are particularly difficult to capture in perspective. To make things a bit easier, sit where you can draw an uphill slope instead.

● 67. Consider your eye level when populating your sketch.

Your eye level is basically the height of your eyes above the ground.
Depending on how high you are, you'll see other people below you (aerial
view), above you (worm's-eye view), or at your eye level (eye-level view).

● Aerial

In an aerial sketch looking
down, other people's heads
are below your eye level.
The figures closest to you are
lowest and largest in your
sketch, the people in the
distance are smaller and their
heads are higher on the page,
closer to your eye-level line.

⊃ GAVIN SNIDER, USA

Grand Central Terminal, One
Week before Christmas

*17" x 5.2" | 43.2 x 13.2 cm;
Ballpoint pen, Sharpie, Ad
Markers in my twin brother
Grant Snider's Shape of Ideas
Sketchbook; 1.5 hours*

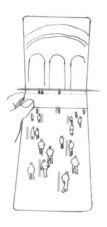

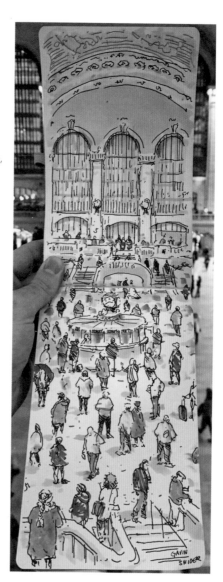

● Eye Level

In an eye-level sketch, heads align at your eye-level line, no matter where the people are standing in your view, close or far away.

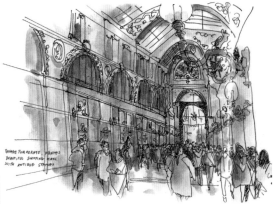

⋂ **RITA SABLER, USA**

Easter Shoppers at the Passage Pommeraye, Nantes

6.5" x 12" | 16.5 x 30.5 cm; Ink and watercolor; 35 minutes

● Worm's Eye

When your eye level is lower than everyone else's, say you are sitting, the heads of people closest to you will appear the farthest above your eye level. The figures in the distance have heads that are also above your eye level, but lower in your sketch.

⋂ **ANNA WILSON, Australia**

Heading Home, Tallinn

6.3" x 6.7" | 16 x 17 cm; Pen, ink, watercolor, gouache, and colored pencil on Saunders Hot Press watercolor paper; About 1 hour

● 68. Your eye level is probably lower than you think.

Oh, how the brain can trick us! What we actually see gets mixed with what we perceive. For example, there is a natural tendency to place your vanishing point too high because we are often looking up a bit.

This is called *floating* because by putting the VP too high in your sketch, you have essentially raised your eye level. You've sprouted wings and are hovering above the ground! Keep in mind that when you are drawing tall buildings or spaces, your eye level and VP are likely very close to where the building hits the ground, probably lower than you think!

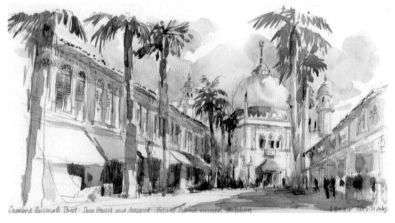

I was sitting on the ground for this view, so the eye-level line is very low on the page. Notice the nearly flat, horizontal lines where the buildings hit the ground.

↻ STEPHANIE BOWER, USA

Bussorah Street, Singapore

8" x 16" | 20.3 x 40.6 cm; Mechanical pencil and watercolor on Fluid watercolor block; 1 hour

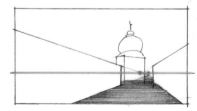

Eye level is too high—you are floating!
We see too much of the ground plane.

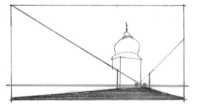

Eye level is nice and low to the ground,
like you!

● 69. Use the "5' Rule-r."

Assuming an average eye level of about 5 feet (1.5 m), you can accurately add elements to your sketch using what I call the "5' Rule-r." Draw a line from any spot on the ground anywhere in your sketch up to the eye-level line. This is an instant 5-foot ruler in perspective!

If you want to draw a table that is 3-feet (0.9 m) high, divide your 5-foot ruler into five approximately equal segments—just eyeball it. Each segment will be approximately 1-foot (30 cm) high in your perspective. Count three up and you've got a 3-foot-high table!

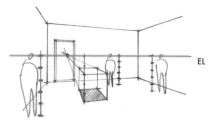

● 70. For furniture, start with the footprint and make a box.

Getting furniture correct is tricky, but it's important because it tells us so much about scale. It's easiest if you think of drawing transparent boxes. Start with the "footprint," draw a box, then shape the furniture from the box. Use the "5' Rule-r" to determine the correct height in perspective.

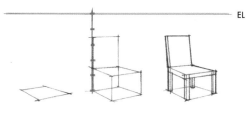

Ɵ STEPHANIE BOWER, USA

Bori's apartment in PA

8" x 16" | 20.3 x 40.6 cm; Mechanical pencil and watercolor on Fluid watercolor block; 1 hour

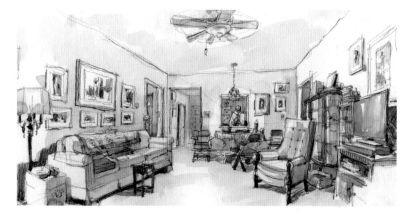

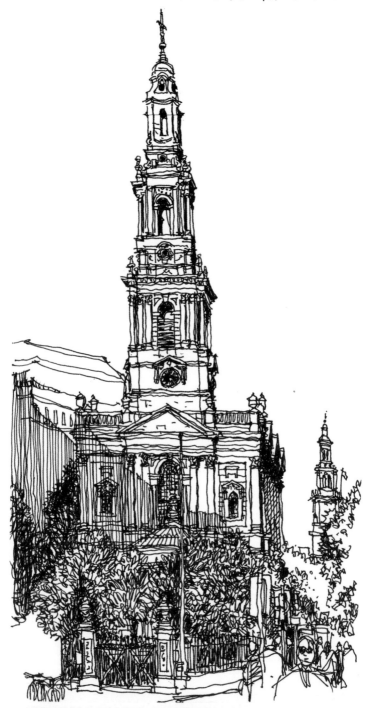

ST. MARY-LE-STRAND

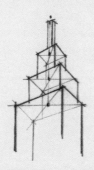

KEY VII

TOWERS ARE LIKE WEDDING CAKES (& OTHER AH-HA MOMENTS)

Sketching complex forms such as towers, domes, and stairs can be challenging, unless we think about them in new ways! Relating complicated forms to simple things we see every day can help to demystify the drawing process.

☾ RICHARD HIND, UK

St. Mary-le-Strand

10.2" x 5.1" | 26 x 13 cm;
Uni-ball Eye Micro permanent
ink pen on double spread of A5
Moleskine sketchbook; 40 minutes

● 71. Use circles and ellipses to draw arches.

Arches are definitely not shaped like horseshoes! An arch is a traditional method of making an opening in a load-bearing wall of a material such as stone or brick. In order to not collapse into a heap, it has certain features.

Arches are symmetrical around a *center line*. Draw a light center line in your sketch for reference.

The *spring line* is a horizontal line that marks where the curve starts. In classical architecture, it's often decorated.

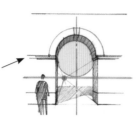

Draw straight legs below the spring line!

The rounded portion is based on some variation of a circle. To draw the shape more easily, lightly draw in the entire circle or ellipse.

Attach the arch to the ground with a dark shadow on the floor.

Don't forget the thickness of the wall and the underside of the curve.

◑ STEPHANIE BOWER, USA

Chiesa di San Donato, Civita di Bagnoregio, Italy

7" x 20" | 17.8 x 50.8 cm; Pencil and watercolor in a Pentalic Aqua Journal; About 1 hour

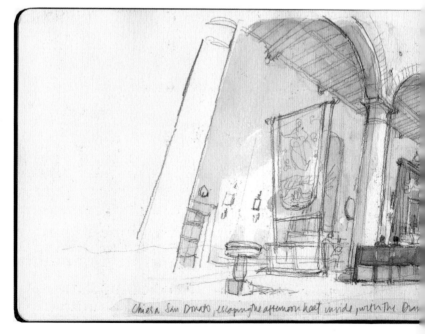

Chiesa San Donato, escaping the afternoon heat inside, with the sun

When seen at an angle or in a two-point perspective, the circle shape is flattened to an ellipse. To draw the arch more accurately, lightly draw in the entire ellipse.

Lightly draw guide lines (light blue) at the spring line and at the tops and bottoms of the ellipses to help you align these shapes in perspective.

> To check the shape of an ellipse, turn your paper sideways or upside down.

n Workshop · Civita di Bagnoregio, Italy S. Bower 17 June 2017

● 72. Domes are round. Lampshades, too.

This may seem obvious, but it can be tricky to make a rounded form like a dome look round! Have you ever noticed sketches in which the edge of the dome seems to have a sharp corner?

The key to drawing this shape correctly is understanding that domes appear as a stack of ellipses, each sharing a common line down the center. Each ellipse appears flatter the closer it gets to your eye level. First sketch these shapes with light construction lines as if they were transparent, starting with one ellipse and adding a center line, then drawing the stack of ellipses about that center.

Drawing the center line will help you align the ellipses and accurately locate the very top of the dome's cupola.

Ellipses appear flatter the closer they are to your eye level (blue.)

Vertical lines get gradually closer together as the form rounds to the backside.

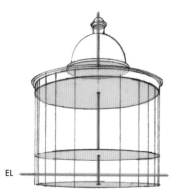

EL

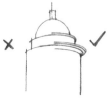

Note the gently rounded profile. This edge should not appear as a sharp corner.

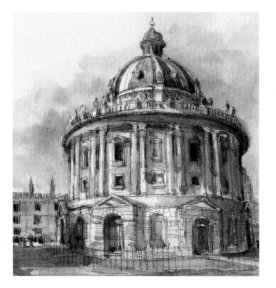

↻ STEPHANIE BOWER, USA

Radcliffe Camera, Oxford

7" x 20" | 17.8 x 50.8 cm; Pencil and watercolor in Pentalic Aqua Journal; 1.5 hours

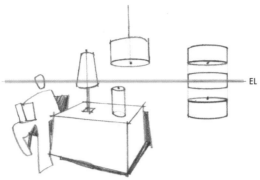

Notice the relationship between the eye-level line (blue) and how the lamps read. When above eye level, you can see up into the lampshade. When below, you see down and into it, but at eye level, we see both a cup-down ellipse at the top and a cup-up ellipse at the bottom of the lampshade.

● 73. Groin Vaults.

If you ever sketch inside a Medieval or Renaissance church or other space that has lots of arches, you are likely to encounter a ceiling shape called a *groin vault*. To make it easier to draw, notice that the vaulted ceiling is actually made up of two arches that cross at diagonals to form an x.

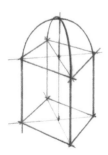

Draw a single curved line that arches up from one corner to the opposite diagonal corner. Repeat on the other corners to form an x. The diagonal arches will intersect at the center line.

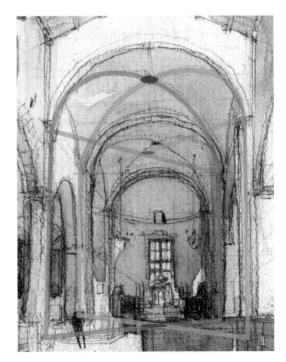

● 74. Stairs are like a wedge of cheese.

A simple way to sketch stairs is to ignore the zigzag of the treads and risers and visualize stairs as a wedge of cheese or slice of cake on its side. Here's how it works in perspective:

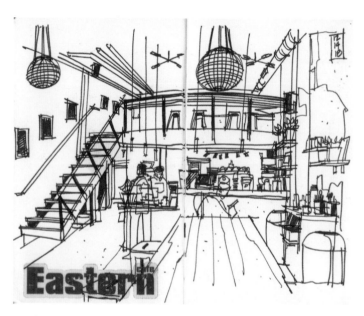

1. Find your vanishing point (orange) at eye level (blue).

2. We know that because the stairs slope up and away, the vanishing point for the stairs will also pop up, directly over the vanishing point at your eye level.

3. Lightly draw a vertical line (gray) through the eye-level VP.

4. Use your pencil to extend an edge of the stair (orange) to see where it intersects the vertical line. This will be your vanishing point for the slope of the stairs!

5. Once the wedge is drawn in perspective, sketch in quick treads in pairs of lines and then small vertical lines for the edges of the risers.

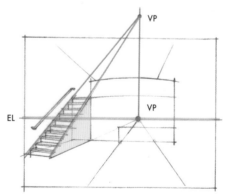

⋂ ANDIKA MURANDI, USA

Eastern Cafe, Seattle

8" x 10" | 20.3 x 25.4 cm; Pen and ink on Moleskine sketchbook; About 20 minutes

● 75. Use the vanishing point to draw a sloped roof.

Picture a sloped roof of tile or standing-seam metal. Like sloped stairs, that angled roof plane also has a vanishing point. And because the roof slopes *up* and away from you, its VP will also pop up . . . but where? Right above the VP at your eye level, of course! Here is a trick for drawing the roof:

**⊃ DON LOW,
Singapore**

Lu Chuan East Street,
Taichung, Taiwan

*8.3" x 11.8" | 21 x 30 cm;
Ink and watercolor; 30 minutes*

1. Find the vanishing point at your eye level (orange).

2. Lightly draw a vertical line straight up from this VP (orange).

3. The seam line on the roof directly above the eye-level VP will appear as a true vertical line (orange), straight up and down. Draw this in first.

4. The roof lines to the left of this line will angle up toward the right, the lines on the other side will angle up toward the left. The farther the lines are from the vertical, the more angled they will appear in your sketch.

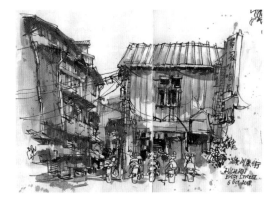

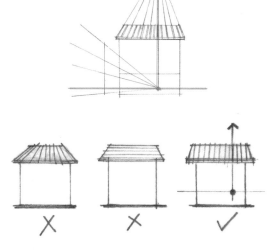

> No matter what material the roof is made from, it's useful to draw lines in the direction of the slope.

● 76. Towers are like wedding cakes.

Imagine a wedding cake. If one layer is off center, there will be a tragic cake collapse and a wedding disaster! The same is true for towers.

Towers and cakes are both a series of stacked round or rectangular boxes that get smaller the higher up they go. To avoid the appearance of imminent danger in your sketch, the key is understanding where the center of the tower is, as this vertical line connects all the layers with the point at the top and keeps everything balanced.

To visualize the stacked boxes, sketch them as transparent wire-frame forms. Be sure to use the vanishing point(s) that are on your eye-level line.

Remember high school geometry? Use diagonals to find the center of one of the boxes, then draw a vertical line up and down from that center (orange). Each layer will be centered on this vertical line, and it gives you the correct location of the very top of the tower.

Notice also that each layer is set back (yellow) from the layer below it.

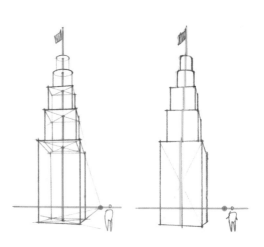

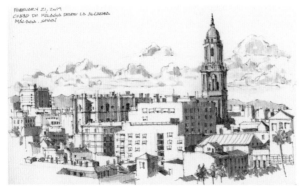

↺ JOSIAH HANCHETT, USA

Málaga from Alcazaba

5" x 8.25" | 12.7 x 21 cm; Ink and watercolor; 2 hours

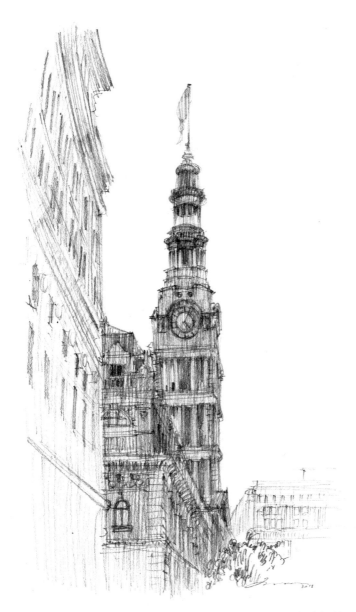

⌒ STEPHEN TRAVERS, Australia

Sydney G.P.O. Tower

10.6" x 15.2" | 27 x 16 cm; 2B pencil and sketchbook; About 30 minutes

The tower in Stephen's delicate sketch looks so stable. The boxes are stacked around a common center line that also connects through each ellipse and to the flagpole on top.

● **77. Think of cars as stacked boxes.**

Once again, we're breaking down complex forms into simple shapes. Think of a car as two, stacked rectangular boxes. Use the vanishing point(s) to draw these forms, then sculpt the shape of the car. Add ellipses for tires, and always draw a very dark, flat shadow underneath to attach the car to the ground.

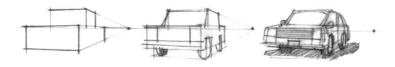

● **78. Trees are like umbrellas.**

To avoid the classic, cartoony lollipop tree, visualize a tree as an umbrella. It has a rounded canopy with light hitting one side, an irregular profile, a dark trunk, and it is attached to the ground with a shadow.

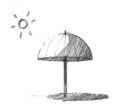

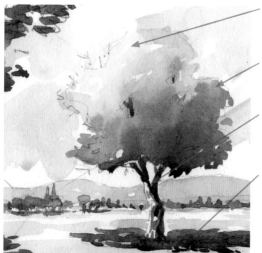

The sunny side of the canopy is lighter with a darker, shady back and underside.

The irregular, broken edge line suggests natural foliage.

Sketch the trunk with irregular, broken lines, and show it as dark, asymmetrical, slanted, or curved.

Attach the tree to the ground with a dark, flat, shadow in the shape of an ellipse with irregular edges.

● 79. Consider the distance of a tree.

When sketching trees, think about them in three different zones. When trees are close to us, we see individual leaves and branches. In the middle ground, we see the overall shape of the tree, its trunk, and we get a sense for clumps of foliage. And in the distance, we see simple masses of trees and no detail.

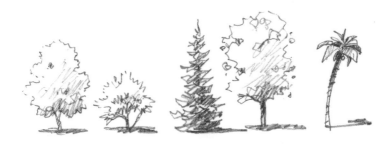

Remember that trees are not flat, so sketch some branches coming forward and some reaching back.

ʊ SHARI BLAUKOPF, Canada

Macdonald Farm

15" x 22" | 38 x 56 cm; Pencil and watercolor; 1.5 hours

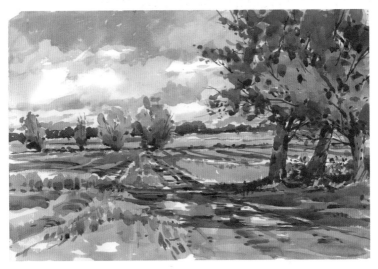

● 80. Sketch people to tell a story.

Sketches of people convey activity and life, and they can be a powerful way to describe daily life, a place, or event.

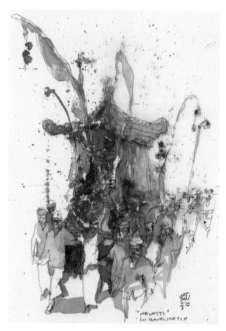

↻ ARTYAN TRIHANDONO, Indonesia

Melasti Parade at Seminyak

12" x 18" | 30.5 x 45.5 cm; Conte pencil and watercolor on paper; 1.5 hours

In Artyan's loose sketch, we sense the activity, color, and movement of this event. There are so many different ways to sketch people!

↺ ROB SKETCHERMAN, Hong Kong

Hong Kong Island Life

6000 x 3375 pixels; iPad Pro, Apple Pencil, Procreate (app); 3.5 hours

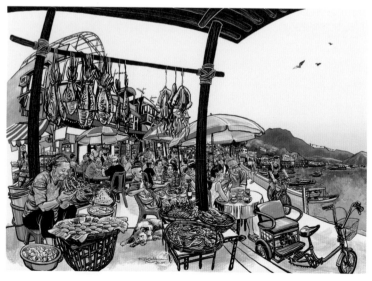

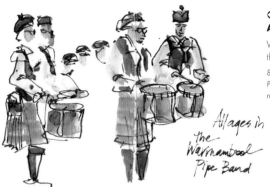

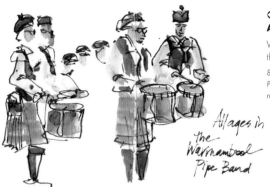

**↻ ANGELA WILLIAMS,
Australia**

Warrnambool Pipe Band at
the Port Fairy Folk Festival

*8.3" x 10.2" | 21 x 26 cm;
Pen, watercolor on Moleskine
notebook; 7 minutes*

● 81. Add people for scale.

Once you drop a person into your sketch, you will immediately
understand how big or small things are.

Here is a simple way to
sketch scale figures fondly
referred to as "bubble
people." Draw a rectangular
trunk, a small oval or egg-
shaped head floating above
the shoulders, and one
leg shorter to suggesting
walking. Add a bit of
clothing, hair, or a bag
for character.

**⊃ STEPHANIE BOWER,
USA**

Duomo Side Door, Florence

*7" x 10" | 17.8 x 25.4 cm;
Mechanical pencil and watercolor
in Pentalic Aqua Journal; 1 hour*

KEY VIII
C'MON IN,
THE WATER IS FINE

Watercolor is fun. Watercolor is frightening.

Watercolor is also the ideal medium for painting on location. It's portable, quick to dry, and yields an infinite range of luscious colors. That said, it is intimidating because of the number of variables to figure out—which paints, which brushes, how will the paper react, how fast or slow will the paint dry in the weather, and so on. And there are no do-overs. Once the paint is down, it's pretty much there.

I like to call watercolor "planned spontaneity." While you have to be strategic about how to apply it, it has to look fresh, like you just splashed it into existence. There are piles of books written about watercolor materials and technique, so here are just a few top tips and concepts. Don't be deterred by thinking you can't paint! There are lots of simple ways to use watercolor. And the joy of dipping your toe in the water can't be beat.

ᴄ ROOI PING LIM,
Australia

Back alley Taiwan Boulevard
Sec. 1, Tai Chung City

11" x 7.9" | 28 x 20 cm; Pencil,
Platinum Carbon pen with black ink
and watercolor on Fabriano Cold
Press paper 300 gsm; 2+ hours

● 82. Get the feel for it.

Watercolor is all about getting the feel for the paints, brush, water, paper, and air. You can read or think about it forever, but ultimately, you have to put brush to paper. A lot. Practice, practice, practice until you know how all these elements interact. Watch people paint in person, up close. Splash, have fun!

● 83. Watercolor works light to dark.

Opaque media, such as oil or acrylic, work dark to light. You start with the dark hues/values, and you end with the spots of light colors or white paint to create a sense of light.

Watercolor, however, is the opposite. Because it is a transparent medium, the whites are provided by the white of the paper. You start with light values and build up darks. While some sketchers paint successfully in only one pass, watercolor is perfect for painting in layers.

● 84. For paint consistency, think of dairy products.

Watercolor is like stained glass. It has to be transparent enough that light can pass through it, hit the white of the paper, and bounce back to your eye for that glorious glow. For this reason, too much pigment in your mix will block the bouncing of light, and too little pigment will leave you with an unsatisfying literally washed-out lack of color. Getting a good ratio of paint-to-water is key.

Try thinking of paint consistency as familiar dairy products, ranging from watery skim milk to heavy cream. You'll start with lots of skim milk that covers most of your paper, and you'll end with little bits of thickest cream that provide contrast and pop in your painting.

FIRST LAYER ···> FINAL LAYER

Skim Milk covers 70-95% of the paper.

This lightest layer establishes lights/darks, unifies the overall painting. Use a large brush.

2% Milk covers 50-80% of the paper.

This layer defines big shapes. Work background to foreground, top to bottom.

Whole Milk covers 20-40% of the paper.

This thicker/darker layer adds more definition to shapes.

Cream covers maybe 5% of the paper.

This thickest/darkest layer adds contrast and detail. Use a small brush.

● 85. Paint in layers.

Painting in layers requires a bit of strategy. Starting with white paper, your first layers will be light and diluted, with each additional layer getting both darker and thicker with more pigment.

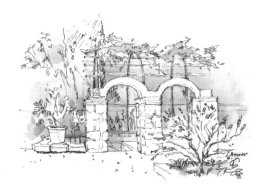

Called *underpainting*, these first diluted skim-milk layers of color cover most of your paper and establish lights and darks, warm versus cool, and what areas advance or recede. Paint right through most of the shapes. Be sure to plan where you will leave white spots for sunlight and sparkle.

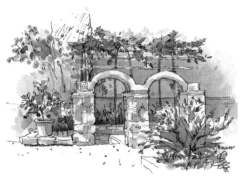

More layers with thicker paint start to add definition to the forms. Paint in shade and shadow to the underside and backside of objects.

There is not a lot of contrast yet, so sometimes this stage is fondly referred to as the "awkward teenage phase." It's a sketch not yet fully formed, but it's well on its way! Push through!

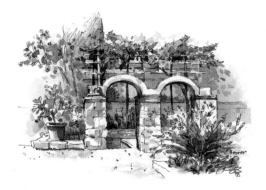

It's the small bits of the darkest and thickest cream paint at the end that make the sketch pop and come alive. A few spots of a bright color such as orange help to enliven the sketch, too.

↻ STEPHANIE BOWER, USA

Tony's Garden in Civita

5" x 8" | 12.7 x 20.3 cm; Mechanical pencil, Winsor & Newton watercolors on Arches 140-lb Cold Press watercolor paper; 1 hour

● 86. Use a limited color palette.

If you are new to watercolor, try painting with only one or two colors until you get the feel for it. You can do almost any painting with just three colors, usually some form of the three primary colors of yellow, red, and blue. Using a limited color palette ensures a harmoniously colored painting.

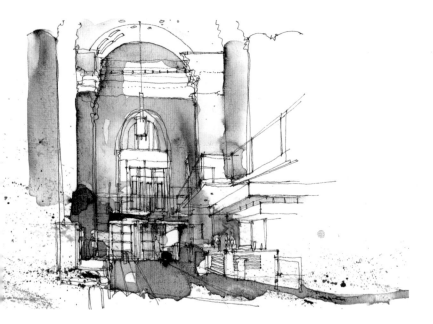

A neutral gray, together with bits of blue and orange, complete this color palette. Notice how only a few dots of orange and blue can balance with lots of gray.

What is your favorite gray to mix?

You can make a gray by combining opposites on the color wheel such as red + green or blue + orange. But for lots of artists, the go-to gray starts with Ultramarine Blue.

For a gorgeous gray, try a combination of **Ultramarine Blue + Burnt Sienna + a tiny spot of Permanent Alizarin Crimson.** Add more blue to make it a cool gray and more Burnt Sienna to have it lean toward a warm brown.

⌒ SIMONE RIDYARD, UK

Interior, Royal Exchange
Theatre, Manchester

6" x 9.8" | 15 x 25 cm; Fine-liner and watercolor on Seawhite watercolor paper; About 30 minutes

● 87. Use one color to make a strong statement.

A single, strong color used strategically can have a powerful, eye-catching impact.

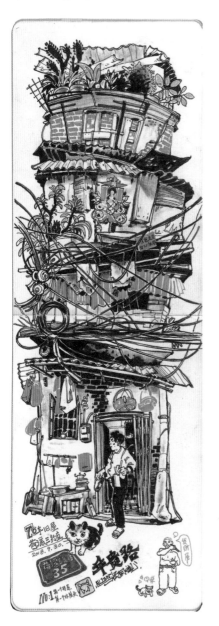

⋒ CHIH-WEI LIN, Taiwan

Golden Shower Tree

8.3" x 8.3" | 21 x 21 cm; Crayon, pen, pencil, marker; 25 minutes

☾ ALIENBINBIN, China

Sketch of Old Street in Guangzhou

16.5" x 8.3" | 42 x 21 cm; Moleskine sketchbook; 3 to 4 hours

● 88. Vary color.

Varying color breathes life, depth, and visual interest into watercolor paintings. Try changing the consistency of the paint (use more or less water) and/or changing the hue (the actual color of the pigment). Mix on your palette or mix on your paper.

Here are five methods for varying your watercolor:

● To vary color, let different colors blend on your paper.

Instead of mixing all the colors on your palette, let different colors mix on your paper. While the paint is wet, drop other colors into the puddle and watch them interact. This is called working *wet-on-wet*.

☝ BEN LUK, Hong Kong

Rose Mansion

12" x 9" | 30.5 x 22.9 cm; Pen, wax pencils, watercolor; 1.5 hours

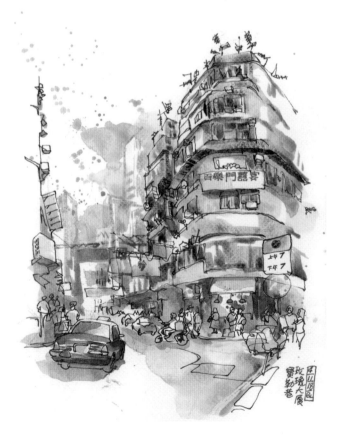

● **To vary color, pick up different colors from your palette.**

Every time you go back to your palette to pick up more paint, change the color a bit. Try picking up random colors and see what happens!

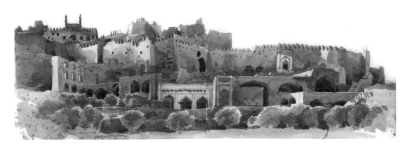

Instead of painting a flat, yellow wall, look at all the colors Zainab layers into her sketch to add depth and richness.

⋂ ZAINAB TAMBAWALLA, India

Golconda Fort, Hyderabad, India

7" x 20" | 17.5 x 50 cm; Lamy Safari, sketchINK, watercolors in Pentalic sketchbook; 1.5 hours

● **To vary color, tilt your paper.**

Let gravity do the work. As your paint drifts downwards on your paper, the colors will deepen, separate, and settle in beautiful ways, revealing the watery nature of watercolor even when dry.

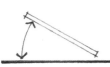

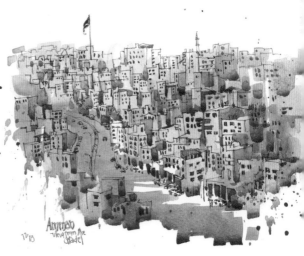

⊃ MONALI HALDIPUR, India

Amman, Jordan—View from the Citadel

9.4" x 12.6" | 24 x 32 cm; Watercolors, Uni Pin Fineline pen 0.4, Fabriano Cold Press watercolor paper 300 gsm; About 2 hours

● **To vary color, change color as you work top to bottom and left to right.**

Think about the sky. Its deepest color is right above you, and it gradually gets lighter and more yellow toward the horizon. Also think about varying color left to right with the side closest to the Sun or light source appearing lighter. Now combine these two for a great sky!

Showing these variations in color adds visual interest and depth to your sketch. Not only is this true for painting skies, it's a great approach to painting most surfaces anywhere in your painting.

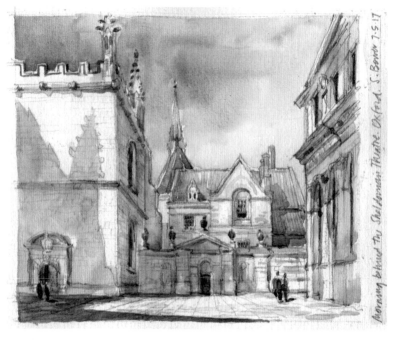

In this sketch, the sky varies in two directions: a deeper blue on the left and lighter on the right; and a deeper blue at the top of the page and lighter closer to the horizon.

Notice all the color variation in the shadows! Quinacridone Burnt Orange dropped in to the gray/purple shadow, while wet, creates a glorious glow of bounced light.

⋒ STEPHANIE BOWER, USA

Behind the Sheldonian Theatre, Oxford

6" x 8" | 15.2 x 20.3 cm; Mechanical pencil and watercolor in Pentalic Aqua Journal; 1 hour

● **To vary color, refer to the color wheel.**

Reference the color wheel by incorporating color families, that is, the color on either side of any given hue. This is called using *analogous* colors. For example, if you are painting an orange, add yellow to brighten and red to deepen the hue.

↻ **STEPHANIE BOWER, USA**

Via dei Cappellari, Rome, Italy

7" x 10" | 17.8 x 25.4 cm; Mechanical pencil and watercolor in Pentalic Aqua Journal; 1 hour

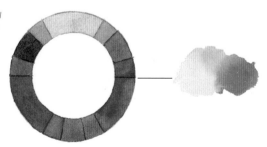

To paint this range of analogous colors, start with Yellow Ochre. While it's wet, drop in Pyrrole Orange and Burnt Sienna and let them blend on the paper.

● 89. Buy the biggest brush you can afford.

Those tiny brushes that come with watercolor kits—they are only good for painting postage stamps! Instead get a big, round brush, say size 8-10-12. You want one that will hold a lot of paint and *also* has a sharp point at the tip. A good, large brush will allow you to make both broad and fine strokes without having to constantly dip back into your palette for more paint.

● 90. Splatter, dribble, and run.

These fun marks add movement and spontaneity to your sketch. Try flicking your paintbrush or using the bristles of a toothbrush. Place your hand or a spare piece of paper over the parts of the sketch you don't want splattered!

⊃ SIMONE RIDYARD, UK

Kuala Lumpur Skyline (from the 25th floor of the Pullman KLCC Hotel)

11" x 6" | 28 x 15 cm; Fine-liner and watercolor on Seawhite watercolor paper; About 45 minutes

● 91. Embrace "accidents."

Pick up the wrong color? Go with it. Get a bloom or backwash as your watercolor dries? Use it. Quite often what first seems like a mistake ends up being the best part of your sketch.

● 92. Shade vs. Shadow in color.

As we saw with values of gray, shade and shadow vary when using color, too. In general, shadow is dark and cool, leaning toward gray-blue-purple hues. Shade is lighter and warmer in color temperature. Just look at the glow you can get by modulating values and dropping in warmer hues while the paint is wet!

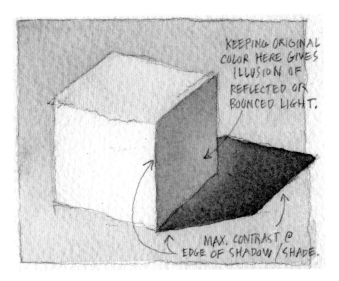

KEEPING ORIGINAL COLOR HERE GIVES ILLUSION OF REFLECTED OR BOUNCED LIGHT.

MAX. CONTRAST @ EDGE OF SHADOW/SHADE.

⋂ JAMES AKERS, USA

Shady Ideas

3" x 3" | 7.6 x 7.6 cm; Water, paint, brush, paper; 20 minutes

Jamie paints a perfect explanation of light, shade, and shadow in color. Decide a direction for the light, and be sure to preserve the whites until the end of your painting.

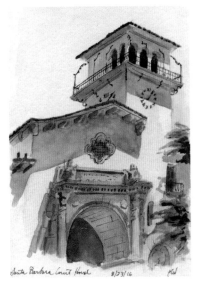

⊃ KATIE WOODWARD, USA

Santa Barbara Courthouse

9" x 6" | 22.9 x 15.2 cm; Mechanical pencil, watercolors, Pigma Micron pens; About 45 minutes

● 93. Use different hues to show depth.

In terms of reading spatial depth in your sketch, warm hues such as yellows and reds tend to appear closer to us. Cool hues such as blues and purples tend to recede from us.

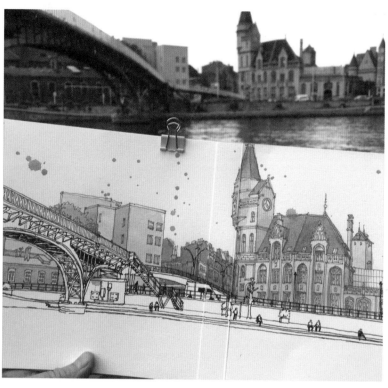

⋒ NINA JOHANSSON, Sweden

View across river Meuse in Liège, Belgium

7" x 19" | 18 x 48 cm; Ink and watercolor; 2 hours

The blue hues of the background buildings help them to recede into the background.

⊃ BIJAY BISWAAL, India

Nagpur Orange

14" x 22" | 35.5 x 56 cm; Pencil and watercolor; 1.5 hours

Midst mostly neutral colors in Bijay's plein air painting, the bright yellows, reds, and blues painted along the eye-level line glow and draw your eye into the sketch.

● 94. Consider big contrasts for impact.

Creating a strong contrast between buildings and their background is important for your overall painting. Consider these two approaches:

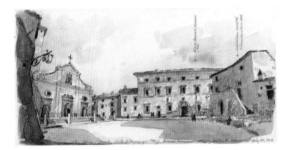

Dark building against a light sky.

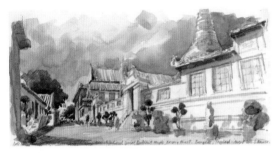

Light building against a dark sky.

↺ STEPHANIE BOWER, USA

Piazza San Donato (top)

Temple, Bangkok, Thailand

8" x 16" | 20.3 x 40.6 cm; Pencil and watercolor on Fluid watercolor block; 1 hour

● 95. Use bright colors to show a lot of activity.

Along your eye-level line, drop in eye-catching colors such as oranges, reds, and bright blues to suggest lots of people and activity. Even random spots of color work like magic to indicate a busy market or street.

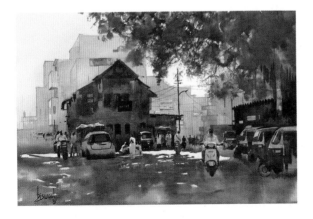

● 96. Show a sense of light, even on a cloudy day.

A diagonal streak of light across a building surface brightens your sketch. Even on a gray day, pick a direction for the light and preserve the white of the paper as you paint.

Alex paints in Paris, a city famed for its overcast skies. The diagonal streak of white paper suggests the angle of the sunlight hitting the building and keeps the sketch lively.

⊃ **ALEX HILLKURTZ, France**

Café Français

11.8" x 7.9" | 30 x 20 cm; Ink and watercolor; 1.5 hours

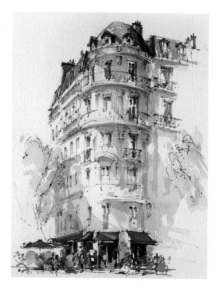

● 97. Skies have perspective, too!

Clouds closer to us appear larger, while clouds in the distance appear smaller and narrower. Instead of painting with flat horizontal strokes, try angled strokes to add movement and perspective. Modulate the color from the foreground to the background in the distance.

⊃ **SHARI BLAUKOPF, Canada**

Footpath

11" x 14" | 28 x 35.5 cm; Pencil and watercolor; 1.5 hours

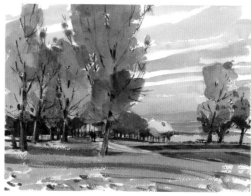

● 98. Add reflections for drama and light.

Water, shiny floors, and glass are but a few opportunities to add a dramatic sense of light to your sketch. In general, dark forms reflect as dark areas, light reflects as light, and those bits of white paper have never been more important!

Reflections, however, are not necessarily perfect mirror images. Depending on the quality of the reflective surface, we often see reflected shapes as elongated and stretched, or with irregular edges.

Consider the nature of the reflective surface. Smooth stone floors reflect light and dark, more or less, straight down. On a rippled surface, like water, the reflection is more irregular.

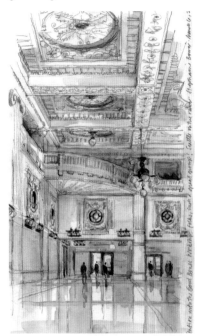

⊃ STEPHANIE BOWER, USA

King Street Station, Seattle

16" x 8" | 40.6 x 20.3 cm; Mechanical pencil and watercolor on Fluid watercolor block; 1 hour

⊃ SHARI BLAUKOPF, Canada

Lake Afternoon

11" x 15" | 28 x 38 cm; Pencil and watercolor; 1.5 hours

● 99. Push colors a little . . .

A gray wall doesn't have to be gray! To enliven your sketch, try pushing the actual colors a little bit—or to extremes.

↻ ALICIA ARADILLA, Spain

La Pedrera, Barcelona

10.2" x 6" | 26 x 15 cm; Pencil, watercolor, marker, and ink; 50 minutes

Gaudí's La Pedrera is really a warm beige, but Alicia has pushed the colors to whites, brighter yellows, and dark grays.

↺ IAN FENNELLY, UK

John Knox House in Edinburgh

11.8" x 15.7" | 30 x 40 cm; Pen and watercolor; 3 hours

Ian blushes his amazing line drawings with color. Here he pushes warm yellows that advance next to cool blues that recede.

. . . or push colors a lot!

↪ MARU GODÀS, Spain

Mission Bay (San Francisco)
After "Gouache Like a Child"
Workshop

13.1" x 13" | 33.4 x 33.2 cm;
Gouache, color pencil, and Neocolor
in handmade sketchbook with Shöller
Hammer matte paper; 45+ minutes

Maru's quick strokes, tilt, and of
course, vibrant colors infuse her
sketches with loads of energy.

↻ ELEANOR DOUGHTY, USA

Yongkang Street, Da'an District,
Taipei

9" x 12" | 22.9 x 30.5 cm; Posca acrylic
paint markers on 120-lb Cold Press paper
in handmade sketchbook; 1.5 hours

Why make a blue sky or a green
tree? Ellie pushes the colors to
extremes for an extraordinary
and whimsical visual effect.

● 100. The most important part of your painting is where you *don't* paint.

Ironic, isn't it? But it's so true! Reserved spots of white paper set off all the other rich and beautiful colors in your sketch. Plan what areas you will leave white *before* you start. As you paint, try picking up your brush a lot to leave bits of white paper between your brush strokes. Make your sketch sparkle!

☊ IAIN STEWART, USA & Scotland

Ponte Vecchio, Florence, Italy

*11" x 9" | 28 x 23 cm; Graphite and watercolor;
About 1 hour*

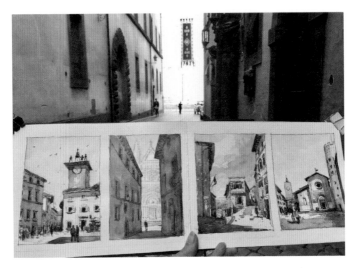

● 101. Enjoy the journey.

◔ **STEPHANIE BOWER, USA**

Streets of Orvieto, Italy

7" x 20" | 17.8 x 50.8 cm; Pencil, watercolor in Pentalic Aqua Journal; 3 hour

It's remarkable how powerful sketching can be. The day that beautiful Notre-Dame cathedral caught fire, those of us fortunate enough to have been there and sketched, pulled out and posted our drawings. This tragedy stirred up emotions for so many people. Why were we in tears?

What we sketch becomes part of our DNA and is forever a part of us. We look so closely, feel the air and hear the sounds around us, and more. We learn about what we see. We are so focused and in the flow that we lose all track of time. We drink it all in and pour it into our sketch. Sketching is truly some kind of magic power, and capturing a moment of our life in a sketch is something remarkable.

So, whether you draw or paint, work at home or on the road, the final tip of this book is to enjoy your amazing sketching journey. It will change how you experience the world in so many ways. Push through the bad days, as good ones will follow. Accept the struggles as part of the process because that means you are learning and growing. The more you sketch, the more rewarding it becomes, especially if you share the experience with others. It's not about the destination, it really is about enjoying how you get there.

See your world better, one sketch at a time.

CHALLENGES

1. ☐ Draw three value scales using different strokes.
2. ☐ Sketch people in a local coffee or tea shop.
3. ☐ Draw people from above.
4. ☐ Draw people from below.
5. ☐ Paint ten different skies.
6. ☐ Sketch a tower like a wedding cake.
7. ☐ Sketch your food.
8. ☐ Try using the 5' Rule-r to draw furniture.
9. ☐ Splatter on your painting.
10. ☐ Let your paints run.
11. ☐ Plan ahead where to leave whites.
12. ☐ Add reflections to a street sketch.
13. ☐ Draw a sloping roof.
14. ☐ Draw a set of stairs.
15. ☐ Sketch people in action.
16. ☐ Draw an open doorway in pencil.
17. ☐ Paint an open doorway in color.
18. ☐ Try five different pens to see which one you like best.
19. ☐ Paint a dark sky.
20. ☐ Compose a sketch using the rule of thirds.

◔ BEN LUK, Hong Kong

Mid-Autumn Festival

8.3" x 8.3" | 21 x 21 cm; Pen and watercolor; 1 hour.

CONTRIBUTORS

Akers, James
USA
www.akersdesignrender.com

Aradilla, Alicia
Spain
IG @a.aradilla

Bajzek, Eduardo
Brazil
IG @bajzek

Bijay Biswaal
India
www.biswaal.com

Blaukopf, Shari
Canada
www.blaukopfwatercolours.com

Bower, Stephanie
USA
FB|IG @stephanieabower

Briggs, Richard
Australia
www.richardbriggs.com.au

Campanario, Gabriel
USA
IG @gabicampanario

Ch'ng, Kiah Kiean
Malaysia
www.kiahkiean.com

Chih-Wei Lin
Taiwan
FB|IG @art_shrimp

Costa, Hugo Barros
Portugal & Spain
IG @yolahugo

Doughty, Eleanor
USA
www.edoughty.com

Fennelly, Ian
UK
IG @ianfennelly

Godàs, Maru
Spain
IG @marugodas

Haldipur, Monali
India
IG @monali.haldipur

Hanchett, Josiah
USA
IG @jdhanchett

Heston, Sue
USA
IG @sue.heston

Heaston, Paul
USA
IG @paulheaston

Hillkurtz, Alex
France
IG @Hillkurtz

Hind, Richard
UK
IG @richhind

Jeong Seung-Bin
South Korea
IG @90gram

Jianzhong WU
Hong Kong
FB|IG @wujianzhong

Johansson, Nina
Sweden
IG @nina_sketching

Kudriashova, Alena
Russia & Singapore
www.mysquiggles.com

Lim, Rooi Ping
Australia
IG @sketching_rooism

Low, Don
Singapore
IG @donlowart

Luk, Ben
Hong Kong, China
IG @sketcher_ben

Meier-Pauken, Klaus
Germany
IG @ Architekturzeichnen

Murandi, Andika
USA
IG @andikamurandi

Reddy, Steven
USA
www.stevenreddy.com

Ridyard, Simone
UK
www.simoneridyard.co.uk

Sabler, Rita
USA
IG @ritasabler

Sae-Aung, Prayut
Thailand
IG @prayutsaeaung

Shi, Zhifang
China
IG @zhifangs

Shirodkar, Suhita
USA & India
IG @suhitasketch

Shmatnik, Andrey
Canada
IG @andreysh555

Sketcherman, Rob
Hong Kong
IG @robsketcherman

Snider, Gavin
USA
IG @gavindedraw

Stewart, Iain
USA & Scotland
www.stewartwatercolors.com

Tambawalla, Zainab
India
IG @zainabtambawalla

Trihandono, Artyan
Indonesia
IG @artyan_trihandono

Travers, Stephen
Australia
IG @stephentraversart

Tryon, Jerome
USA
IG @jerometryon

Woodward, Katie
USA
IG @ramblingsketcher

Williams, Angela
Australia
IG @lunchsketch

Wilson, Anna
Australia
www.annawilsoninink.com

Yang Guo Bin
China
IG @alienbinbin

IG is Instagram
FB is Facebook

ACKNOWLEDGMENTS

There are so many extraordinary sketchers around the world, and it's my honor and privilege to feature a small handful here. Thank you to these amazing artists for sharing their work. I am in awe of your talent.

To the community of Urban Sketchers in every pocket of the globe, you change lives, including mine. I've found my tribe, and I'm forever grateful.

To Mary Ann Hall and the team at Quarry Books, your creativity is here, too! Thank you!

Gratitude beyond words to my family and friends whose amazing support makes all this possible.

Finally, my heartfelt thanks to the many years of many students, you have all taught me so much.

ABOUT THE AUTHOR

Stephanie Bower pours her many years as a teacher, illustrator, architect, and traveling Urban Sketcher into *101 Sketching Tips*. Also author of the fourth book in this series, the *Urban Sketching Handbook: Understanding Perspective*, she is the go-to instructor for all things regarding perspective.

Stephanie worked as a licensed architect in New York City before gravitating to professional architectural illustration and concept design. In Seattle, she produces pencil and watercolor images for many renowned architecture and design firms. She was twice-honored with the KRob Architectural Delineation award for Best Travel Sketch and was the 2013 Gabriel Prize architecture fellowship recipient.

For more than twenty-five years, Stephanie has taught the how-to's of architectural sketching—for a decade in New York City at Parsons, in Seattle at the University of Washington and Cornish College of the Arts, and more recently, in sketching workshops called "Good Bones." She has taught at six Urban Sketchers Symposiums, teaches workshops around the world and online, and she is a signature member of the Northwest Watercolor Society.

Stephanie continues to learn about architecture through her sketches, pursuing her lifelong dream of seeing the world, sketching, teaching, and encouraging others to see their world through the magic of drawing.

Website and workshops: www.stephaniebower.com
Blogs: Drawing Perspectives (www.stephaniebower.blogspot.com) & www.urbansketchers.org
Instagram: @stephanieabower
Facebook: stephanieabower.Seattle
Online classes: www.mybluprint.com (formerly Craftsy)